DRAWING WORKBOOKS
PEOPLE

Bruce Robertson

NORTH LIGHT BOOKS

Cincinnati, Ohio

Dedication
To Frank Wood –
unique art teacher

Acknowledgement
Many of the drawings are by students or members of
the Diagram Group. Wherever possible they have
been acknowledged in the captions. The following
are acknowledgements to libraries and museums who
own the works of famous artists.
p10 Henry Fuseli: Victoria and Albert Museum, London
p24 Albrecht Dürer: Staatliche Museum, West Berlin
p36 Vincent Van Gogh: I V W Van Gogh
p37 Rembrandt: British Museum, London
p41 Juan Gris: Museum of Modern Art, New York
p43 Albrecht Dürer: Museum of Fine Art, Boston
p46 Vincent Van Gogh: Fogg Museum, Harvard University, Massachusetts
p52 William Blake: Tate Gallery, London
p60 William Hogarth: Mansell Collection, London
p62 Kathy Kollwitz: Fogg Museum, Harvard University, Massachusetts
p63 Ben Shahn: Museum of Modern Art, New York
p63 Hans Holbein: Royal Library, Windsor Castle, England

Artists
Joe Bonello
Alastair Burnside
Helen Chapman
Richard Czapnik
Stephen Dhanraj
David Gormley
Brian Hewson
Richard Hummerstone
Mark Jamil
Lee Lawrence
Paul McCauley
Victoria Ortiz
Kathleen Percy
Anne Robertson
Jane Robertson
Michael Robertson
Graham Rosewarne

Guy S. R. Ryman
Ivy Smith
Mik Williams
Marlene Williamson
Martin Woodward
Zoë Ullstein

Typographer
Philip Patenall

Editors
Carole Dease
Damian Grint
Denis Kennedy

Cover illustration by
Graham Rosewarne

© Diagram Visual Information Ltd 1987

First published in Great Britain in 1987
by Macdonald & Co (Publishers) Ltd
London & Sydney

ISBN 0-89134-230-3

Published and distributed in the United States by North
Light Books, an imprint of F&W Publications, 1507 Dana
Ave., Cincinnati, OH 45207

DRAWING WORKBOOKS

THIS BOOK IS WRITTEN TO BE USED.
It is not meant to be simply read and enjoyed. Like a course in physical exercises, or any study area, YOU MUST CARRY OUT THE TASKS TO GAIN BENEFIT FROM THE INSTRUCTIONS.

1. READ THE BOOK THROUGH ONCE.
2. BEGIN AGAIN, READING TWO PAGES AT A TIME AND CARRY OUT THE TASKS SET BEFORE YOU GO ONTO THE NEXT TWO PAGES.
3. REVIEW EACH CHAPTER BY RE-EXAMINING YOUR PREVIOUS RESULTS AND CARRYING OUT THE REVIEW TASKS.
4. COLLECT ALL YOUR WORK AND STORE IT IN A PORTFOLIO, HAVING WRITTEN IN PENCIL THE DATE WHEN YOU DID THE DRAWINGS.

Do not rush the tasks. Time spent studying is an investment for which the returns are well rewarded.

LEARNING HOW TO DO THE TASKS IS NOT THE OBJECT OF THE BOOK, IT IS TO LEARN TO DRAW, BY PRACTICING THE TASKS.

WORKBOOKS ARE:
1. A program of art instruction.
2. A practical account of understanding what you see when you draw.
3. Like a language course, the success of your efforts depends upon HOW MUCH YOU PUT IN.
 YOU DO THE WORK.

- Drawing is magical, it captures and holds your view of the world. Once produced, the drawing is eternal: it says 'This is how I see the world at this place in this time.' It tells of your abilities and your circumstances.
- Drawing is a self-renewing means of discovering the world, and its practice is self-instructive. You learn as you go along and you improve with practice.
- Drawing is a universal language understood by everyone. It is also a concise and economical way of expressing reality and ideas.
- Drawing is a state of consciousness. You lose yourself in the drawing as you become involved in your responses to what you see. It has a calming effect when you feel depressed, agitated, ill or dissatisfied. You are outside yourself. Everyone can learn to draw. Be patient and try hard to master the skills.

TOPIC FINDER

Drawing PLACES

Places, or landscapes, have long been the most popular subject for artists to draw. The 19th-century Impressionists were mainly concerned with recording their observations of landscapes. All landscape drawing is a form of gazing through a window. The recessional space, or feeling of depth, of a scene has to be captured on the flat surface of the paper.

Landscape drawing can be an obsession. Once you begin drawing, you begin looking, and once you begin looking, you begin seeing. Reality is a wonderful thing. It is never constant. It offers millions of interpretations. You will be constantly surprised by your discoveries.

Going out sketching is like setting off on a voyage of discovery, the rewards of which last your whole life. Your drawings will not only be committed to your memory, they will also transmit to others an experience you had and which they can share.

Drawing is selecting, never more so than with landscape studies. Try always to choose simple compositions, simple views, simple groups of objects. So often beginners are discouraged because they attempt too much too quickly.

Be selective when you draw landscapes. The world is too full of detail, and the time too short to record every tiny feature. Drawing is not copying nature, it is looking and seeing and missing out the unnecessary. Your drawing reviews what you find interesting in the world. Study it carefully.

Work slowly. One fully detailed study is worth lots of half-attempted studies. With practice, every subject is possible. Remember, you bring the most important ingredients to your landscapes. They are enthusiasm, confidence, curiosity and the willingness to complete a study to the best of your abilities.

CONTENTS

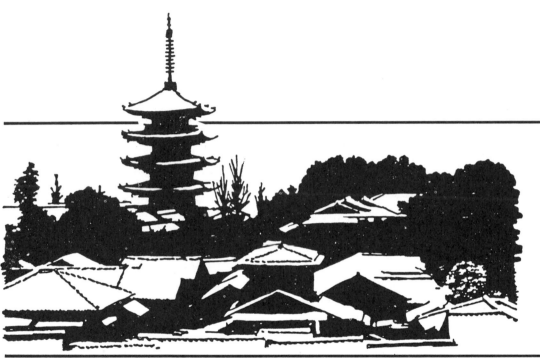

Chapter One LOOKING AND SEEING

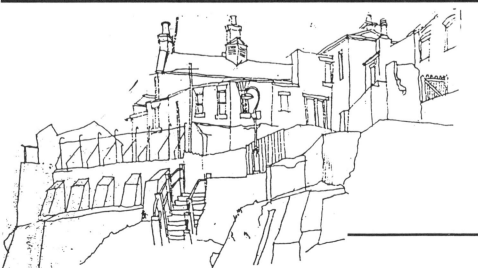

Chapter Two UNDERSTANDING WHAT YOU SEE

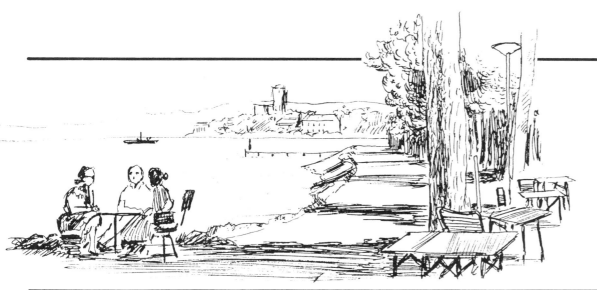

Chapter Three MASTERING TOOLS

Chapter Four CONSIDERING DESIGN

CHECKING YOUR PROGRESS

You may not do all the tasks in the order they appear in the book. Some require you to research sources of photographs or other artists' works, some direct you to museums and art galleries, and some may be done quickly while others can only be completed when you can devote more time to their study.

To help you keep a record of your completed Tasks, fill in the date against each numbered Task in the space given beside it.

TASK 1	TASK 31	TASK 61	TASK 91	TASK 121
TASK 2	TASK 32	TASK 62	TASK 92	TASK 122
TASK 3	TASK 33	TASK 63	TASK 93	TASK 123
TASK 4	TASK 34	TASK 64	TASK 94	
TASK 5	TASK 35	TASK 65	TASK 95	
TASK 6	TASK 36	TASK 66	TASK 96	
TASK 7	TASK 37	TASK 67	TASK 97	
TASK 8	TASK 38	TASK 68	TASK 98	
TASK 9	TASK 39	TASK 69	TASK 99	
TASK 10	TASK 40	TASK 70	TASK 100	
TASK 11	TASK 41	TASK 71	TASK 101	
TASK 12	TASK 42	TASK 72	TASK 102	
TASK 13	TASK 43	TASK 73	TASK 103	
TASK 14	TASK 44	TASK 74	TASK 104	
TASK 15	TASK 45	TASK 75	TASK 105	
TASK 16	TASK 46	TASK 76	TASK 106	
TASK 17	TASK 47	TASK 77	TASK 107	
TASK 18	TASK 48	TASK 78	TASK 108	
TASK 19	TASK 49	TASK 79	TASK 109	
TASK 20	TASK 50	TASK 80	TASK 110	
TASK 21	TASK 51	TASK 81	TASK 111	
TASK 22	TASK 52	TASK 82	TASK 112	
TASK 23	TASK 53	TASK 83	TASK 113	
TASK 24	TASK 54	TASK 84	TASK 114	
TASK 25	TASK 55	TASK 85	TASK 115	
TASK 26	TASK 56	TASK 86	TASK 116	
TASK 27	TASK 57	TASK 87	TASK 117	
TASK 28	TASK 58	TASK 88	TASK 118	
TASK 29	TASK 59	TASK 89	TASK 119	
TASK 30	TASK 60	TASK 90	TASK 120	

LOOKING AND SEEING

You begin drawing places by going there or by copying photographs taken on location. The first chapter is your path to exploring your observations of the world outside your room.

You will find thirty-two Tasks to sharpen your judgement of what you see. Good drawing is 90 percent good observation. Look carefully, record accurately, and interpret what you see intelligently.

- The first two pages, 6 and 7, contain the most important idea in the book – places recede from you and contain solid objects – but you have only a two-dimensional surface on which to record them.
- Pages 8 and 9 suggest where, when and how you draw your pictures out of doors.
- Pages 10 and 11 encourage you to seek ideas for your drawings in photographs and other artists' works.

- The next four pages, 12 to 15, direct your attention to the surface of your subject. Observe its light and dark features (tones), and its textures and colors.
- Pages 16 to 19 advise you on ways of looking at the scene: first as flat shapes interlocking to form areas of patterns on the surface of your paper and then as points set at varying distances in space but recorded in only two dimensions on the surface of your drawing.
- Finally, page 20 recommends you to re-examine your work and expose it to the criticism of others by placing your drawings on view on a notice board.

All objects take up space and are set in space. Reality is solid, it has bumps and hollows. The world is a display of colors, shapes, textures and tones, which combine to offer hints as to the volume and space of the subject you draw. Drawing places is the art of interpreting these features on a flat, usually white surface.

Edges of fields
Top right, this drawing by Jane, aged 11, carefully records the textures of the trees, but does not convey correctly an impression of depth in the field.

Hills
Right, drawing valleys is an excellent introduction to capturing space. Each subsequent hillside pushes the obscured hills further and further into the background. Roads and streams help to reveal the folds and bumps by forming a spatial net over the surface.

TASK 1

Tracing space
Right, place tracing paper over this drawing or those on pages 27 or 53. Using a soft pencil or felt-tipped pen, draw lines that travel across the surfaces of the hills. This exercise helps you think spatially, and helps you understand the variations in landscape forms.

TASK 2

Seeing into the distance
Draw a scene with a far distant view in which you can see for more than a mile. Try it from the top of a building or hill. This helps you study the recessional features of a composition.

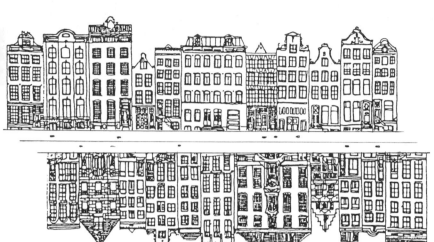

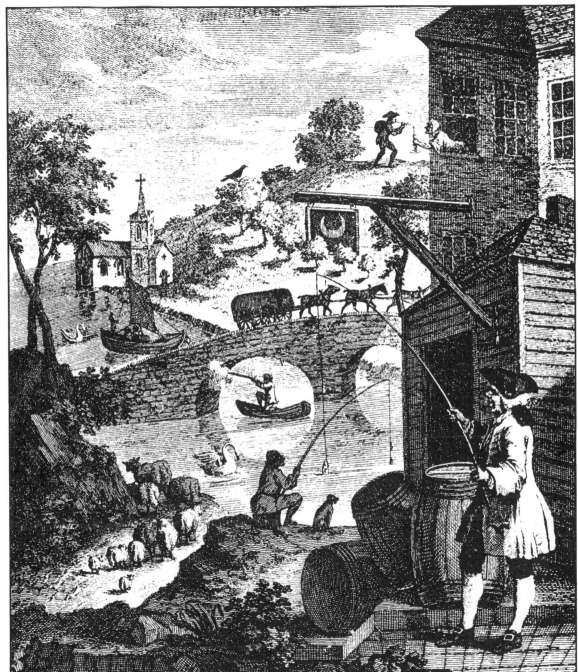

7

Canal houses

Above, in many respects the houses in this view are correctly drawn. They have vertical sides, are comparable in size and all have bases along the canal bank. Most importantly, they face across to their correct opposite building. But as a drawing, it is not a record of one vital feature of landscape drawing – it has no single point of view. Where is the observer supposed to be standing? In reality those buildings furthest from us would be drawn smaller than those nearest to us.

False perspective

Right, a drawing by the English 18th-century artist William Hogarth produced to illustrate by errors the major features of landscape drawing.
1. Figures in the distance should be smaller than those in the foreground (note the lady leaning out of a window is the same size as the man on the hill).
2. Distant objects cannot overlap foreground objects (note sign of Inn).
3. Only one view of an object is possible at one time (note both ends of church).
4. Base points are horizontal (note foreground floor appears to fall away).

TASK 3
Reducing scale
Draw a row of houses from one standpoint and notice the recessional features of your drawing. Things appear to get smaller.

TASK 4
Consistent scale
Draw the same row of houses but this time stand in front of each house in turn so that the windows and roof lines are always horizontal. Compare the proportional relationships on both drawings. This helps you check whether you draw what you think you see or what you actually see.

©DIAGRAM

Working out of doors offers the most challenging and enjoyable experience of drawing. The world is an infinitely variable place with fascinating opportunities to record your impressions. Always allow enough time for the amount of detail you wish to include.

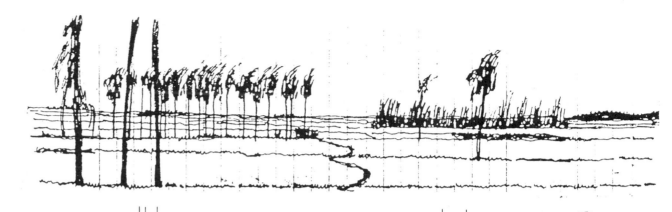

TASK 5
Keeping records
Buy a small pocket sketch pad, no bigger than 6 in × 4 in (15 × 10cm), and carry it with you regularly, making small drawings of views you like.

1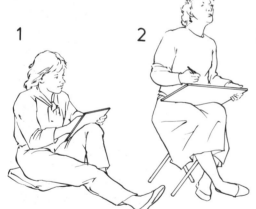

2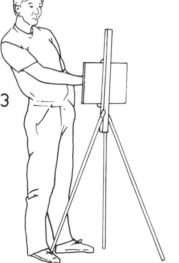

3

Sitting comfortably
Above, left to right, the position you occupy when you are drawing outside influences your ability to concentrate on the subject.
1. Always find a simple fixed position from which to observe the subject. Sit on a wall, bench, tree or comfortable perch.
2. When purposefully sketching outdoors, take a small folding seat.

3. For more lengthy studies use a small easel as this enables you to hold the drawing surface vertical and parallel to your picture view.

TASK 6
Timing yourself
Do a drawing of a landscape taking only six minutes. Sketch the main features as accurately as possible.

TASK 7
Examining reality
Do a drawing of the same subject as Task 6 from the same point, taking sixty minutes and adding as much detail as possible.

Capturing reality
Above left, transferring your impressions to the drawing board is a key element of maintaining an accurate record. Try not to move your attention through a wide arc from subject to board.

Wherever possible, place the board as directly parallel as you can to the direction of the subject you are drawing.
Hold the board as if it were a lower half of a window through which you are looking.

Passing impressions
Left, view from a train while crossing south China. The identical features of the many fields and trees we traveled through for over an hour enabled me to compile this sketch.

Observing detail
Two drawings by Jane, aged 7 years, made while traveling by air. The observed details of the opposite side of an airplane cabin (below), or the company logo on the tail of the airplane (right), will be remembered when later drawing from memory.

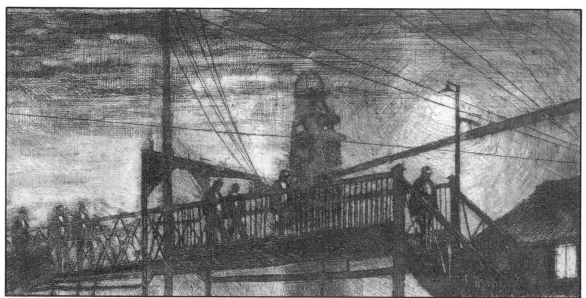

New York
Below left, actual size sketch made while on a ferry that was moving directly and slowly toward the buildings at the lower end of Manhattan.

Night study
Above, first drawn in daylight, then later revisited and reworked to achieve the effect of a late-night industrial scene.

TASK 8
Night scene
Visit a site at night where you can sit or stand under a light. This may be a bus or railroad station. Make a drawing working with chalks or watercolors so that you can apply large areas of dark tone. Capture the spirit of night.

Drawing from photographs is not a matter of copying the different degrees of shading. Photographs can be used to build your confidence. They offer views of places you may never have the opportunity to visit. As they are a record of light upon a flat sensitive surface, they capture shapes and tones that may not at first be noticed when observing reality.

Beginning an idea
Photographs can be used to stimulate ideas for pictures. The availablity of the photograph means you can re-examine it for further details, or see it in terms of a collection of gray shapes.
Far right, a photograph of the rooftops of Kyoto, Japan. Right, a landscape experiment from the Kyoto photograph that brings out contrasts of white and gray, not possible working on-the-spot in the cold of the winter.

Exploring composition
Photographs offer the opportunity to redraw the scene. Changing parts of the composition by moving them, or enlarging them, or even omitting them. Right, sketch of shoppers in Rotterdam appears spontaneous, but it is made from a photograph (far right) taken in a busy street.

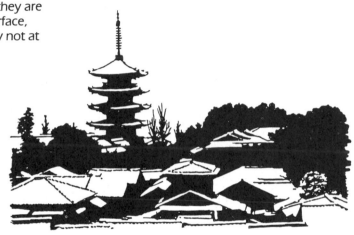

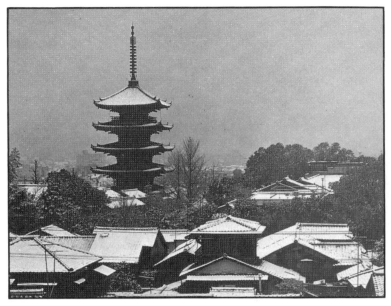

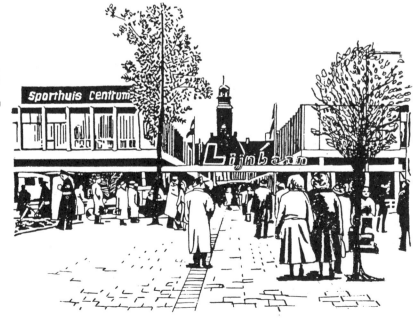

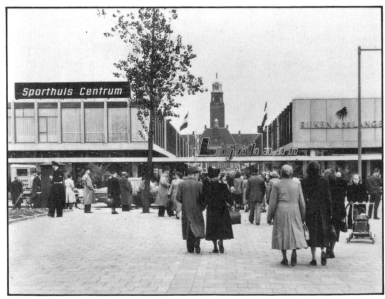

TASK 9

Visual archives

Collect postcards and magazine photographs of subjects that interest you. Travel brochures are a good source of exotic locations. Old books often have illustrations of cities and the countryside which can be used for study.

TASK 10

Cross checking

Take a camera on a walk, using the viewfinder to help you select a composition. Photograph a subject you have already drawn and then compare the prints with your study.

TASK 11

Tonal awareness

Stand this book upright, open at this page. Support it at the back and then copy the central areas of this photograph as if you were viewing the scene from a window. Try to record as accurately as you can the tonal values (grades of shading) of the roofs and shadows.

TASK 12

Spatial awareness

Try a small sketch of the central areas of this picture as if you were viewing the buildings from directly above. This is an excellent test of your understanding of the spatial qualities of the subject. Only after completion, compare your results with the illustration on page 20.

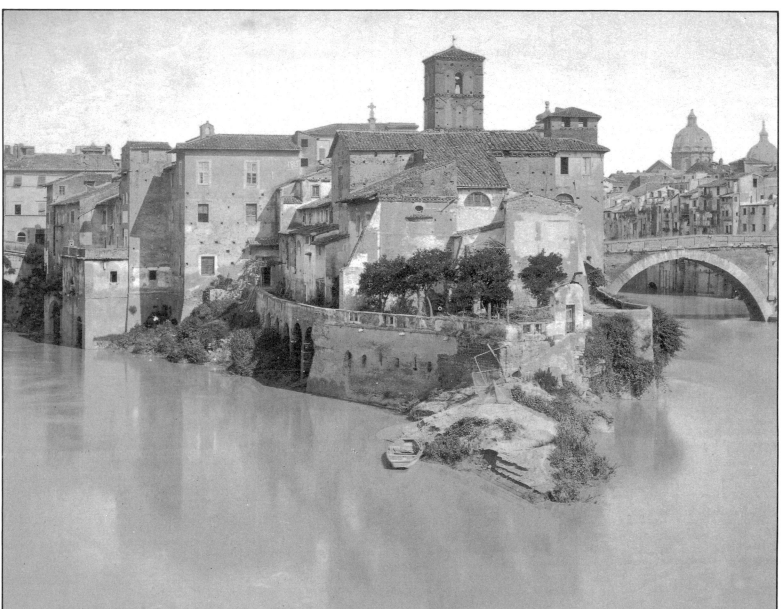

©DIAGRAM

Almost all landscape studies have at the time they are drawn only one single light source, the sun. Surprisingly, beginners often fail to use this feature when drawing what they see. Color, textures and how they think things look, obscure their use of light and dark. Pictures drawn with strong lighting rely on the eye looking carefully at how surfaces jut out or recede from a form, which can be shown simply by how the shadow is cast.

Building facades
Very easy to sketch under a strong Mediterranean light. Balconies protrude, windows recede.

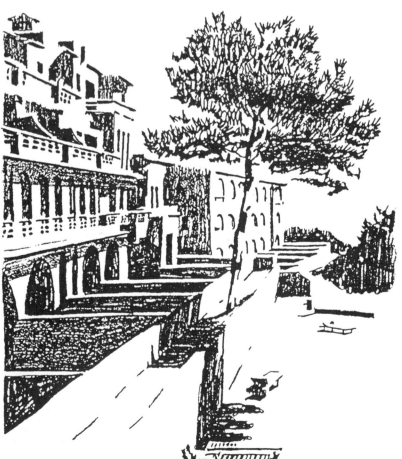

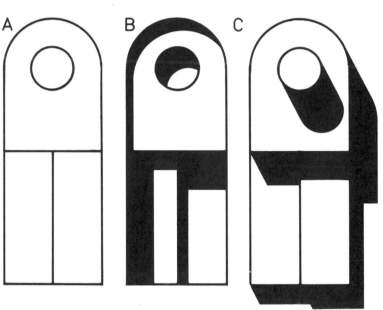

Shadow sketching
Left, the pencil drawing records only the shadow and ignores the textures and colors and forms of the buildings.

Raised or lowered
Above, shapes which are drawn with line only (**A**) could represent any spatial arrangement. The drawing (**B**) clearly indicates a receding facade and drawing (**C**) a protruding one.

TASK 13
Recession and protrusion
Above, place tracing paper over this line grid and using a soft pencil, create shadows from a constant direction to indicate which of the surfaces is raised or lowered on the grid.

Shadow studies
These studies of a home, showing only shadows, create their form by controlling the direction of light and ignoring the other surface qualities.

TASK 14
Observing shadows
Place tracing paper over any of your previous drawings and draw only the shadows.

TASK 15
Creating light and dark
Right, place tracing paper over this drawing of a suburban scene, and without retracing any of the lines of the drawing, shade in shadows as if the sun were falling from behind you and in the direction of the dotted lines.

TASK 16
Changing light sources
Repeat the previous Task, but imagine the sun is falling from behind the car at a low level.

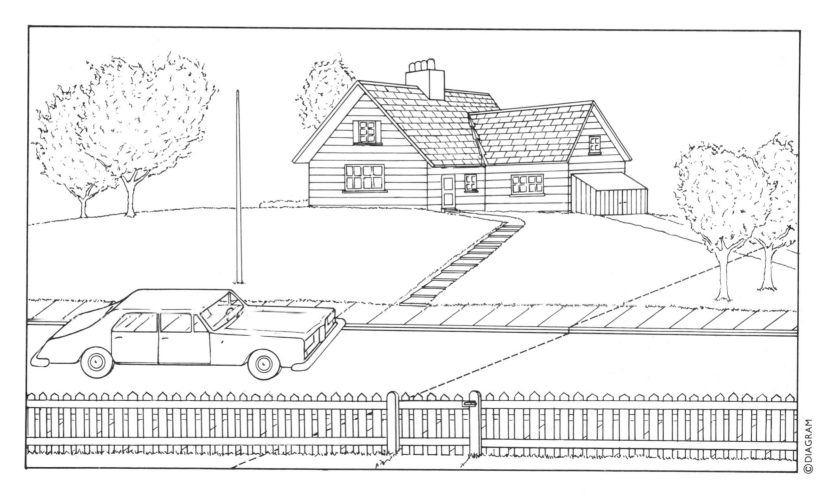

©DIAGRAM

The surface of objects very often creates a profusion of detail which confuses the beginner. Drawing *every* tile on the roof, *every* leaf on the tree, *every* brick in the wall, presents the beginner with a daunting obstacle. Nevertheless, attempting to draw a picture in which part is produced with great care, and which records every possible observable detail, is a rewarding activity.

TASK 17
Studying detail
Draw a section of a brick wall, garden, park, or any objects outside, taking great care to observe and record all the small details in lines only. If this is not possible, place tracing paper over the drawing (below) and lightly outline the main structures. Then, placing the tracing paper on a white background and with a fine pen, detail some areas of the drawing as in the example (right).

Country cottage
This pen and ink drawing is by the American architect Richard M. Powers. It is reproduced here smaller than the original drawing. A window section (below) is reproduced actual size so that you can judge the scale of the detail.

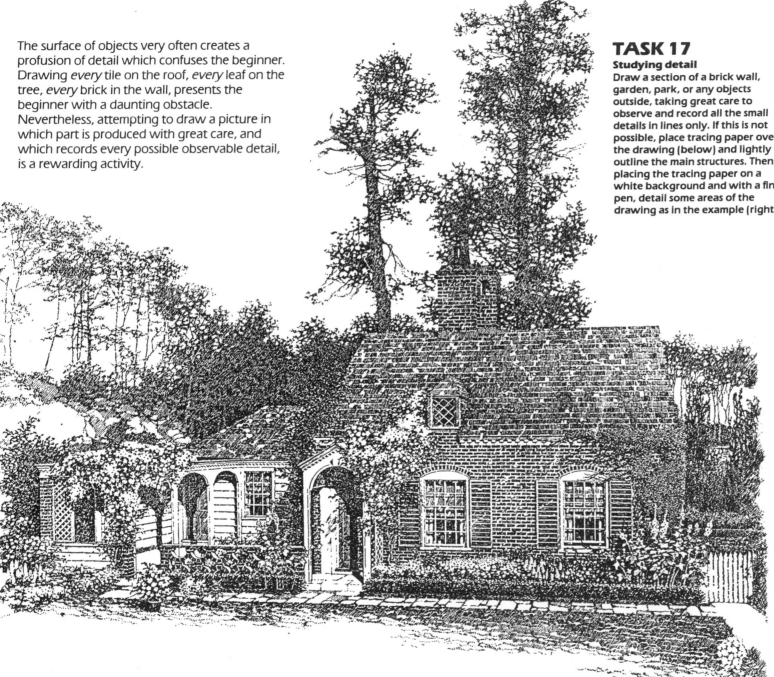

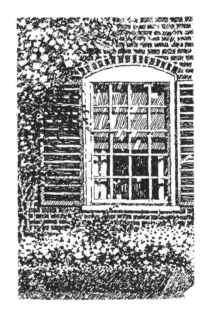

TASK 18

Studying color

Redraw with colored pencils the subject of Task 17. Take great care to keep the points of the pencils constantly sharp and draw only the colored areas of the detail. Again, if you have no access to a subject, place tracing paper over the outline drawing (below right) and, very carefully, add detail in the colors you think most likely. Always add very small areas of color and do not generalize.

TASK 19

Studying tones

The very subtle tonal values of a subject must be recorded accurately if you wish to capture some of the character of the objects. Use the subject of Task 17 to produce a drawing recording only the tonal aspects. As a guide, you can half close your eyes and squint at the subject to reduce their complexity to a more simple tonal pattern. If an outdoor subject is not available, use the outline drawing (right) and tracing paper to convert the detailed drawing (opposite) into a tonal exercise.

TASK 20

Matching tones

It helps your drawing ability to be able to judge tonal values with accuracy. Practice carefully, building up gray areas so that they do not reveal the individual pencil lines. Using soft pencils and cartridge paper, copy some of the areas on these pencil-shaded examples (above). Fold over your study so that the tone is on the folded edge, then place it against these examples to test your judgement.

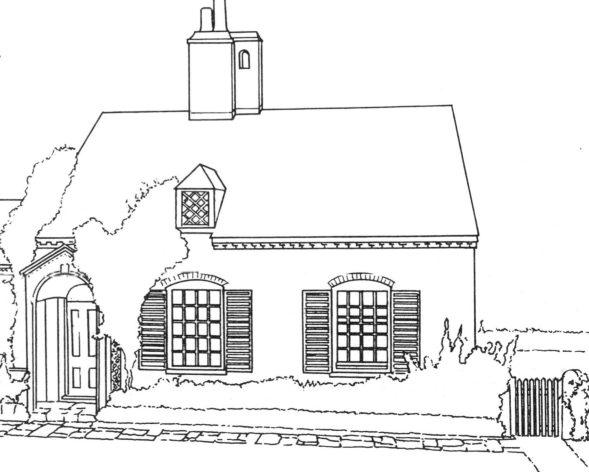

©DIAGRAM

The next four pages direct your attention to methods of checking your accuracy. The first two pages consider the flat interlocking of shapes; the second two pages, the recessional positioning of points in space.

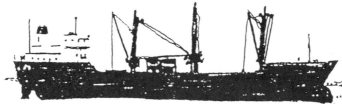

Silhouettes
The most conspicuous feature of objects is their outline shape. Buildings, trees, hills, lakes, all have observable edges between them and the space they occupy. Above, the boat and shore were drawn in Cuba against a blue sky and sea. Their solid qualities, color and tones were ignored in the search for their shapes.

TASK 21
Flat shapes
Draw a scene recording only the skyline and, where possible, outlines of objects in the middle and foreground. Choose a city scape, group of hills, or trees in full leaf, seen against the sky.

The shape of space
A good method of constructing a drawing is to check the outline shapes of each part, one against the other. Check both vertical and horizontal alignments, as if the scene were a flat photograph. The lake view was used because of the clear distribution between flat and irregular surfaces.

TASK 22
Flat space
Draw a lake, a twisting path, or coastline. Take great care to record the edges of the smooth flat areas against the textured surrounding areas.

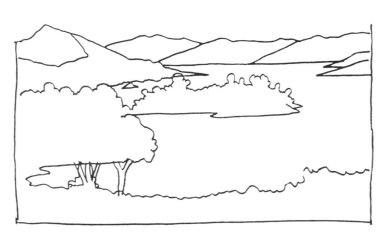

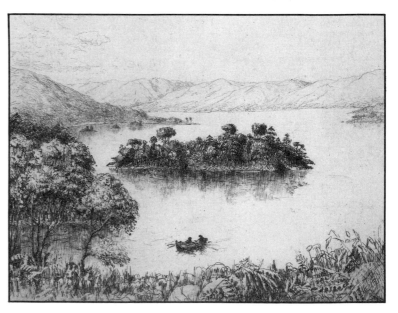

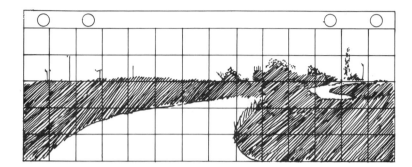

Grids
Seeing shapes that are often irregular and infinitely variable as you change your viewpoint is best accomplished by either working on gridded paper (graph paper) or viewing the scene through a grid.

TASK 23
Grids
Revisit the scene of Task 7 and redraw it on graph paper, taking care to record the shapes accurately.

TASK 24
Viewing Grids
Draw a grid of squares the same size as these (right) on to a window or a sheet of clear plastic placed upright in front of your view. Carefully record the irregular shapes as they cut across the horizontal and vertical lines on to tracing paper over this grid. Artists very often square up their drawings for enlargement and use this grid method to check the shapes.

© DIAGRAM

Landscapes are not an assembly of flat shapes, although seeing them as such helps record them accurately. All objects stand in recessed space. From a normal viewpoint, you must take care to show how and where they stand if you wish to capture the inner space of a picture.

The stars
The stars in the sky all appear to be on a flat dark background. Above, three stars seem to form a triangle but may not have this relationship in space. Below, in space, the stars are often millions of miles beyond each other, yet are always viewed on the same plane in a photograph or drawing.

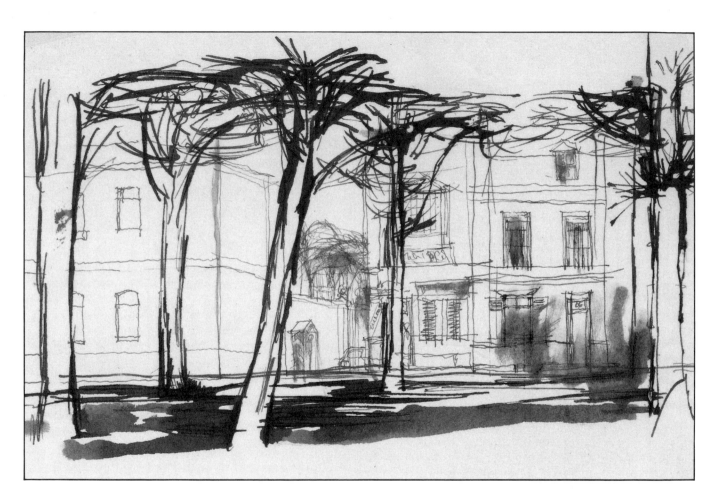

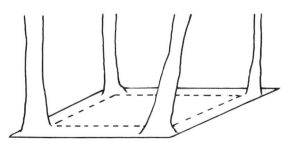

Base points
Above, from overhead these trees form a square. Seen from the side they appear to be almost in a line with one another. Always try to retain the concept of spatial relationships when recording the base of objects.

TASK 25
Base points
Draw a group of trees or separate standing objects such as cars in a carpark. After drawing the group, redraw them from another position where the bases take up a new relationship. Sketch a plan of the group and see if your drawing reveals this.

Figures on beach
Right, the clear area of sand makes an ideal background to judge the depth of position into the picture of the figures and trees.

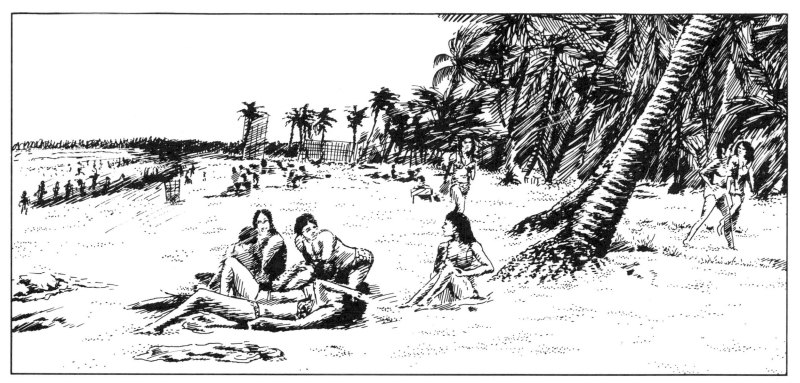

TASK 26
Checkered space
Right, thinking of the base of space areas as a checkerboard helps you plot the positions. Draw a tiled floor with objects laid on it, taking care to look 'across' and 'into' the space.

TASK 27
Base point checks
Plot base points on to photographs, city squares, beach scenes, carparks, harbors. All have strong horizontal situations on to which are laid, as if small toys, the individual objects.

TASK 28
Thinking spatially
Make a sketch plan of the foreground of the buildings on page 11. Draw a plan of the buildings, trees, car and fence in the picture on page 13.

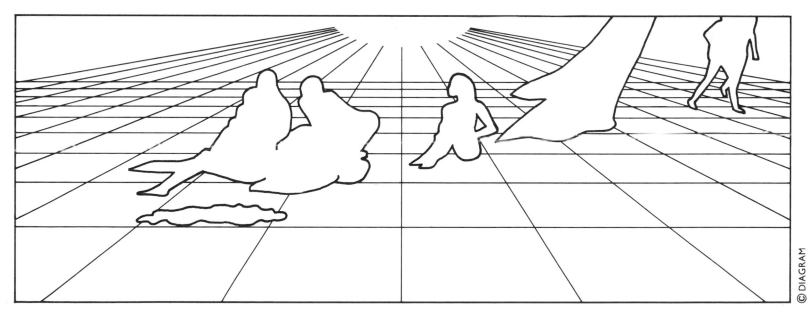

© DIAGRAM

20 Review

Accurate observation

The previous group of Tasks were to teach you to look carefully at the subject you are studying. Constantly re-examine your observations and the scene in front of you. The correct way of looking helps you record accurately your impressions and by a slow process of care, you will produce excellent landscapes.

TASK 29
Re-checking

Revisit the location of Task 7 and check your drawing against the subject for tonal values, textural values, shapes, spatial plotting and an accurate description of the inner space.

TASK 30
Observable accuracy

Compare this drawing by Lee, aged 17, with the photograph on page 11 and see if his study and yours both record the tones correctly.

TASK 31
Presentation

Check that you have signed and dated all your drawings in pencil in the corner. Then make a notice board of hardboard or cardboard and display your best drawings on it for criticism by your friends and, most importantly, by you.

TASK 32
Artistic vision

Copy in pencil a reproduction of a famous painting. Take care to match the tones and shapes of the original.

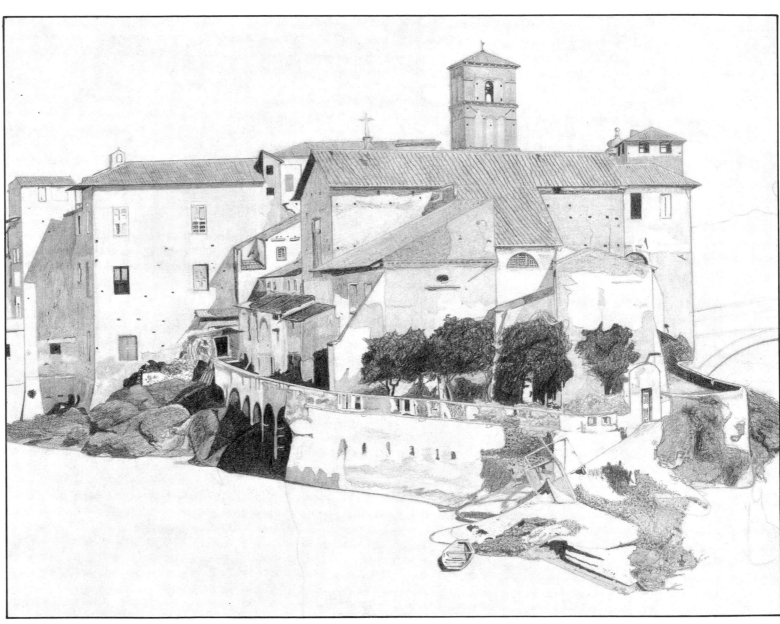

©DIAGRAM

UNDERSTANDING WHAT YOU SEE

This chapter describes how to achieve a spatial quality in your drawing – how to make your picture seem to recede into the page. The simple laws of perspective can help you to achieve a sense of reality and, although thought of as a complex 'mathematical' system, the basic principles are very simple and can be easily mastered.

● The first two pages, 22 and 23, invite you to step into space. Consider the drawing techniques used by artists to project objects into a recessional area.

● Pages 24 and 25 highlight a very simple principle: objects appear smaller as they recede into the distance.

● Pages 26 to 29 describe a very common technique used by artists to achieve this spatial effect. Objects in the foreground are drawn overlapping those behind them, and objects in the distance have a grayer and less detailed quality than those closer to the viewer.

● Pages 30 to 37 explain in basic terms the most frightening of topics for beginners of landscape drawing – perspective. This is the law of constructing a picture to comply with the Western 'civilized' view of drawing space. As a method of drawing it is not natural to either a child or an uninitiated draftsman. Perspective is really only of value as a means of checking what you see, and not a system to be imposed over your observations as a rigid set of laws.

● Finally, page 38 helps you to review your work after thirty-six Tasks.

Every object occupies space but a drawing of it can only be flat. The main task of a draftsman is to describe the three-dimensional world using a two-dimensional medium. A drawing is not a model of the subject, it is a flat description.

Spatial transference

Right, you view objects as if through a glass surface called a PICTURE PLANE. This imaginary flat surface is at right angles to your view. Points in space are transferred on to the plane along lines from the objects to your eyes. Objects seen flat have a proportional reduction of width (**A**) and height (**B**), but have a distorted reduction of depth (**C**).

Properties of space

Right, as you will see in the drawings, there are five main properties of objects you see in space.
1. Scale. The doors appear smaller as they recede.
2. Location. Where they are in relation to your view of them.
3. Diminishing surface details. The bricks on the wall appear to be smaller on walls further away.
4. Overlap. The near wall will appear to be in front of the other walls because it obscures some of their surfaces from your view.
5. Haze. A very distant wall would not have distinguishable features.

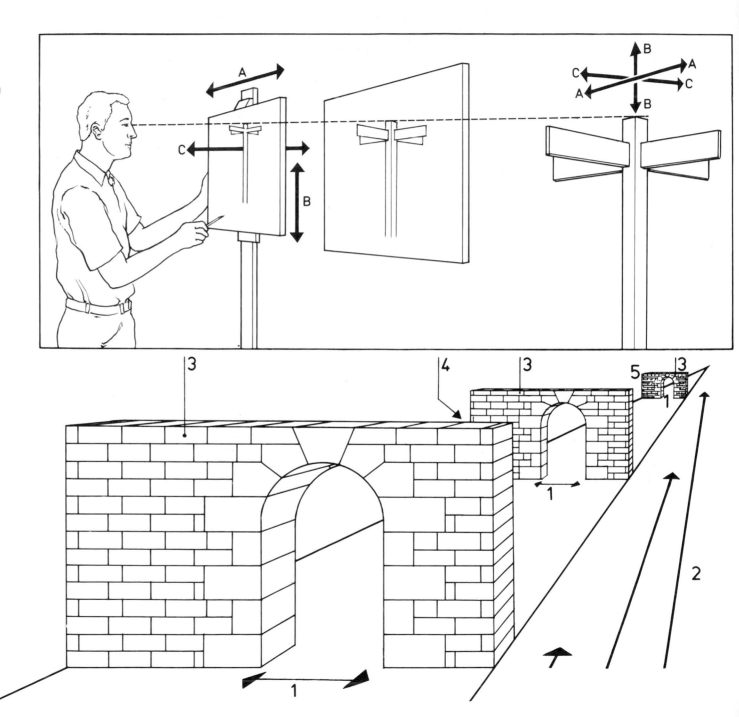

Drawing space
Right, the sketch of Rotterdam shopping area uses all five techniques to describe space.
1. The scale of objects.
2. The location of objects.
3. The diminishing surface details.
4. The overlap of objects.
5. The haze of distant objects.

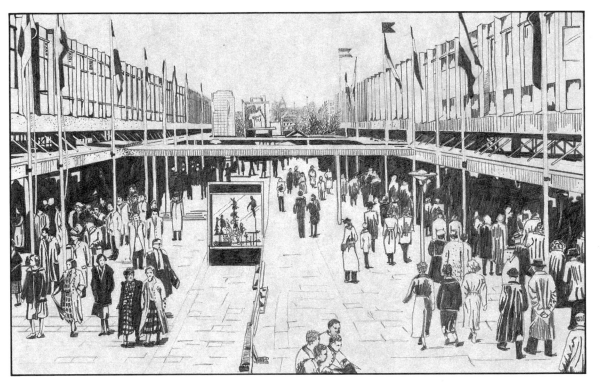

TASK 33

Placing objects in space
Draw a landscape with a group of similar-sized objects in space. Try rows of telegraph poles or trees of similar height.

TASK 34

Plotting bases
Draw a landscape with objects the bases of which can be clearly related – boats in the harbor, or cows in a field.

TASK 35

Observing texture
Draw a landscape with objects that have a common texture, such as a row of buildings or similar types of trees.

TASK 36

Studying overlap
Draw a landscape with overlapping objects, perhaps branches of trees, or a rooftop view of houses.

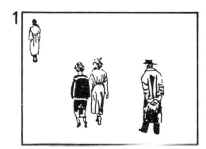

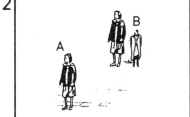

1 Scale
Figures in the drawing represent people of average height, but those in the distance are drawn smaller than those in the foreground.

2 Location
The placing of a figure in the picture helps locate its position in space. Figure **A** represents a figure of the same size as figure **B**, but if they were placed side by side in the picture, **A** would appear larger.

3 Surface
As objects recede, our ability to observe individual small features decreases. We see more textures on foreground surfaces than on distant ones.

4 Overlap
A figure or object in front of another hides part of the one behind. It is this depletion of the surface of the second one that places it behind the first.

5 Haze
Drawings are usually on white paper, so drawing the distant objects in lighter tones than those in the foreground helps them to recede into the picture. This graying also occurs in nature as the air between us and distant objects makes them appear fainter than those in the foreground.

Objects appear to be smaller the further they are from your view. An object near you offers more of its top surface than one further away. Working with lines enables you to draw the foreground objects with more specific lines than those in the distance, which can only be drawn in general terms.

Shrinking shapes
All objects appear to diminish in size in proportion to the distance they are away from you. Their reduction will occur at a regular rate if they are evenly spaced apart.

City rooftops
The windows in the buildings are mostly the same-size, yet those in the distance can only be represented by tiny dots. Those in the foreground can have the individual glass panes drawn in as these would be visible at this distance.

TASK 37
Diminishing detail
Draw a facade of buildings flat on to your view, so that the windows can be drawn all the same size. Move your position to near one corner of the building and redraw so that the distant windows are smaller.

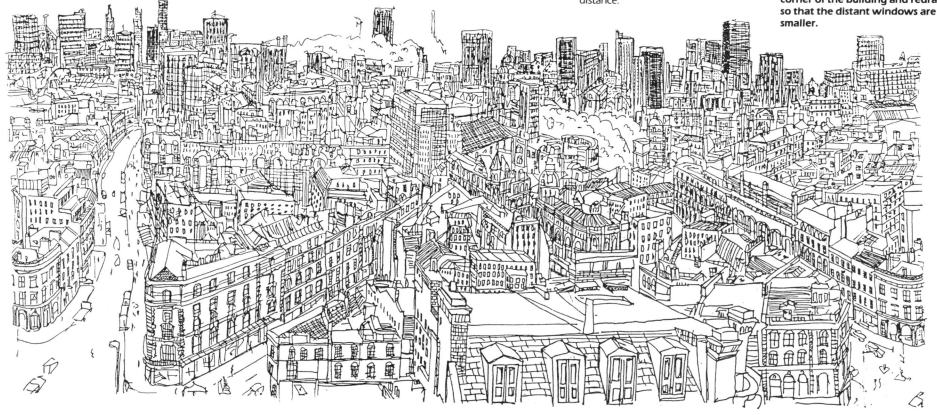

Seeing tops

An object closest to the horizon – your eye-level view will appear almost side view. You will be unable to see much of the top surface. Objects close to you will reveal more of their top surface as they approach your picture surface.

TASK 38

Seeing on top

Place two books of similar size on a long table, one at either end. Sit at a distance from one end of the table and draw both books in one view. Notice how the further one presents less of its top surface to you than the nearer one.

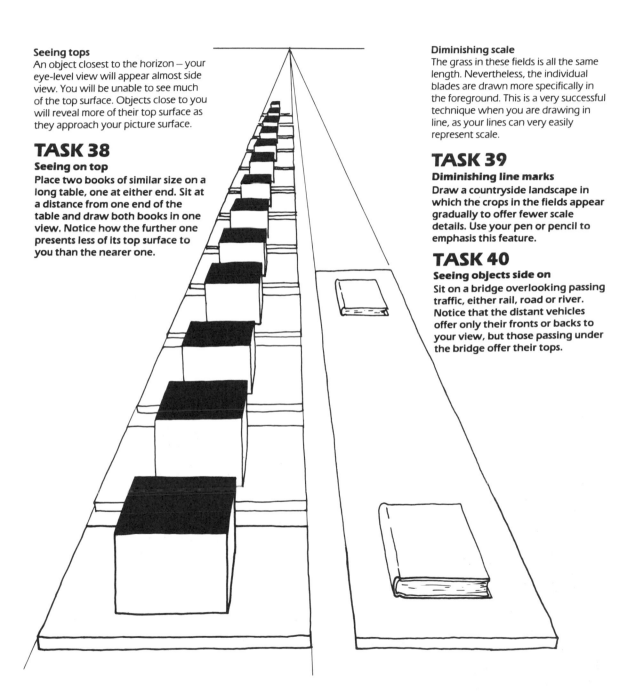

Diminishing scale

The grass in these fields is all the same length. Nevertheless, the individual blades are drawn more specifically in the foreground. This is a very successful technique when you are drawing in line, as your lines can very easily represent scale.

TASK 39

Diminishing line marks

Draw a countryside landscape in which the crops in the fields appear gradually to offer fewer scale details. Use your pen or pencil to emphasis this feature.

TASK 40

Seeing objects side on

Sit on a bridge overlooking passing traffic, either rail, road or river. Notice that the distant vehicles offer only their fronts or backs to your view, but those passing under the bridge offer their tops.

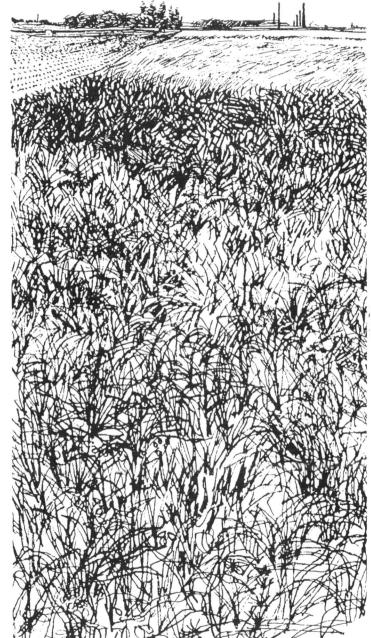

© DIAGRAM

Overlapping the shapes in a drawing is one of the clearest ways to make them appear to be set into the space of the composition. The normal convention of drawn lines means that objects can be very economically described by this technique.

Traditional overlapping
Right, the drawing by an 18th-century Japanese artist uses overlapping to place figures in front of and behind the bamboo screen.

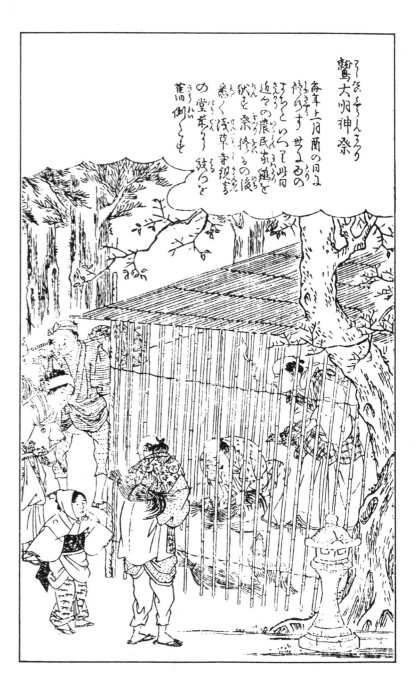

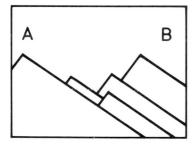 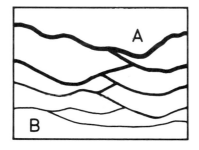 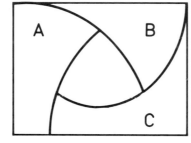

Overlap
Mountain **B** is clearly four mountains behind mountain **A**, and although **A** and **B** are drawn the same height on the picture plane, **B** must be larger if so far into the composition.

Line quality
This group of overlapping lines has little space value. It is hard to estimate whether area **A** is much in front of area **B**. But when reviewed upside down (turn the book around), then **A** is clearly a foreground area. This effect is produced both by overlapping and by increasing the line thickness.

Receding surfaces
The three areas **A**, **B** and **C**, each overlap one another. Because they are inter-related they cannot be parallel to the picture plane and must bend beneath each other.

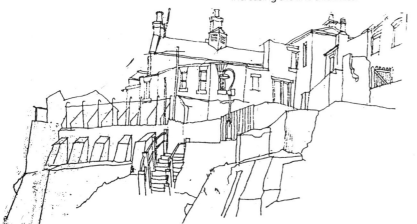

TASK 41
Overlap practice
Draw a subject that has fences, roofs, or walls that overlap. Draw a tree in winter and examine the overlap of the main branches.

Landscape
Below, this drawing has none of the normal features of reality. There are no tones, colors, textures, scale or hazy distance. The drawing relies on describing the rocks by the technique of line overlap.

TASK 42

Conversion to line

Redraw one of your earlier Tasks using only outlines to describe the positions of the objects in the space of your composition.

TASK 43

Line solution

Draw the scene in the photograph on page 20 (a view of Rome) in lines only, making the foreground group of buildings appear ahead of the distant ones by drawing them in stronger lines.

TASK 44

Facets and planes

Below, this drawing uses tones to describe the irregular surface of a newspaper. The bottom drawing copies the subject study but restricts the description to the use of lines. Crumple up an old newspaper or draw the ruffled sheets and

blankets of a bed. Either study can be of help if you do not have access to sketching a mountain range. You can also copy location photographs of hills and mountains.

©DIAGRAM

Objects seen at a distance appear to lose their sharp qualities. The shadows are weaker, there is less definition of detail and the colors all have a blueness. This is because the intervening air acts to subdue the colors and shades of distant objects. To discover how much light dims distant objects, view your subject through half-closed eyes, squint at the distant objects.

The effects of distance
The examples on pages 12 and 13 show how shadows illustrate the subjects' surfaces. The shadows make areas come forward or go back. Right, the drawings describe the box-like elements of the buildings which, when seen close up, (bottom) have protruding side and center buildings. As you recede from the subject (center and top), so it becomes less distinctive, more unified as a single surface.

TASK 45
Judging tones
Very often beginners fail to spot the diminishing tonal values, so draw distant objects as dark as near ones. To test your abilities at assessing tones, estimate where on the graded scale (left) the three patches of tone appear.

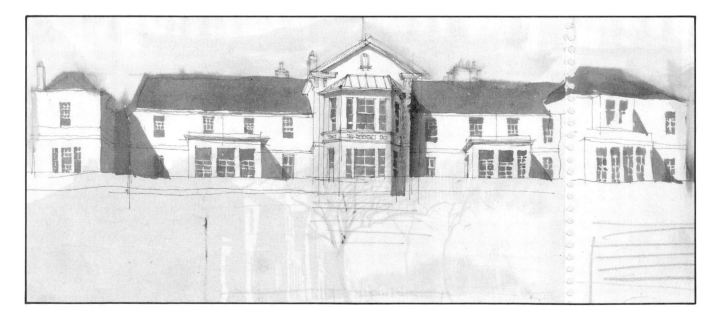

TASK 46
Diminishing details

Draw a building or group of trees from three points, each further away than the other. Notice that the details of the contrasts of shadows will be reduced as you move further and further away from the subject.

TASK 47
Receding space

Below, place tracing paper over this design and shade the areas to make it appear as if the shapes are receding into the page. Keep the patterns of tone of near equal value in the center, either light or dark. Give the shapes around the frame very strong contrasting tonal values, dark and light. The design will appear like a view down a tunnel.

Winter afternoon

Below, drawing of a view from a window. The winter sunlight of an afternoon made the distant trees and fences appear dull and misty.

TASK 48
Atmospheric changes

Draw a row of gardens or houses, or a subject where regular objects recede from your view. Do the drawing on a dull day when there is little sunshine. Use a soft pencil or brush and watercolor. Try to capture the tonal values accurately.

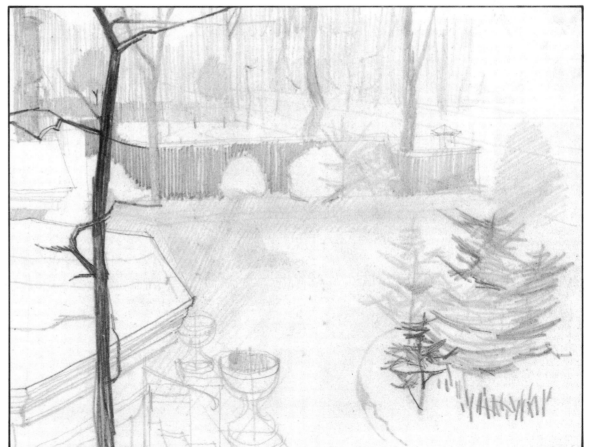

© DIAGRAM

To a beginner, the subject of perspective is a frightening challenge. The 'laws of perspective' seem to be a mixture of geometry and mathematics — a complex group of laws producing nets of lines. But the world around is clearly indicating these laws. Perspective is only the science of understanding what you see. Its only value and interest is in that it enables you to record more accurately your responses to what you see.

Eye level
The line at the level of your vision. Always horizontal, but very often not the horizon line, as the ground may be higher or lower than your standpoint.

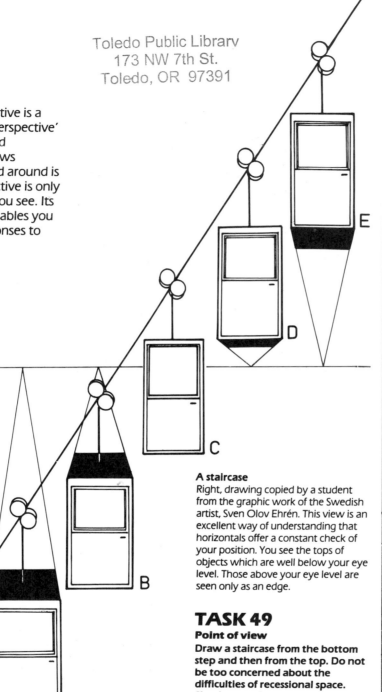

Ski lift
An object passing across your vision reveals different aspects of its surfaces as it moves up or down. Objects beneath your eye level show their top surfaces. Objects above show their underside.
A. Objects well below you reveal a large area of their horizontal surfaces.
B. As the objects come closer to your eye level, you see less of the top surfaces.
C. When level with your eyes, top and bottom surfaces disappear and you have a complete side view. .
D. As objects rise, you see more of the underside.
E. When the object is well above your position, you see a great deal of the underside.

A staircase
Right, drawing copied by a student from the graphic work of the Swedish artist, Sven Olov Ehrén. This view is an excellent way of understanding that horizontals offer a constant check of your position. You see the tops of objects which are well below your eye level. Those above your eye level are seen only as an edge.

TASK 49
Point of view
Draw a staircase from the bottom step and then from the top. Do not be too concerned about the difficulties of recessional space. Simply record as accurately as you can the top surface of each step.

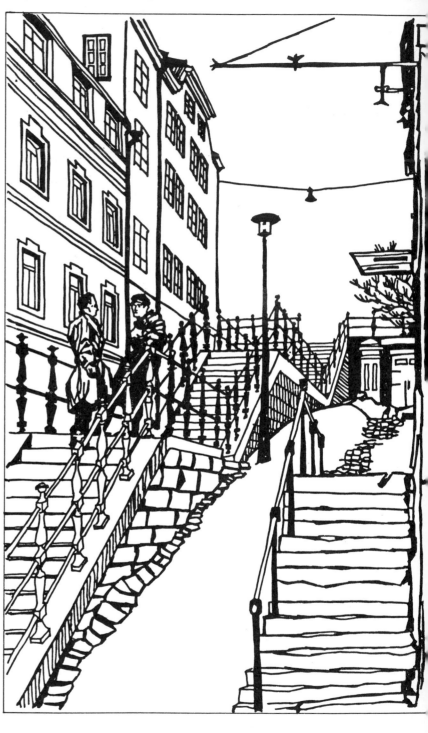

Rules to remember
1. Objects seen flat on and from afar have vertical sides and horizontal features. Both the vertical and horizontal elements are parallel to similar parts on the object.
2. Objects seen at an oblique angle: you see more than one side, and if viewed from afar they have vertical sides but converging horizontals.
3. As you approach the subject the vertical parts appear to converge. This rule is true when looking up at a subject (**3**), or down (**4**).

1

2

3

4

Vanishing points
Parallel lines, when extended, appear to converge on the horizon – a railroad track, for instance, seems to meet in the distance. Right, this drawing aboard a cargo boat clearly shows the parallel lines of the rails getting closer together.

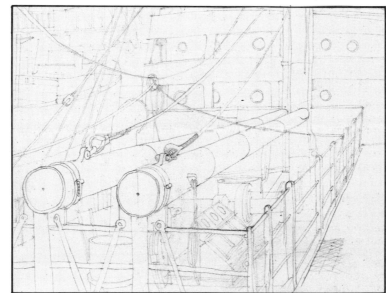

©DIAGRAM

TASK 50
Converging lines
Stand on a bridge overlooking a river, road or rail track. Very carefully record the converging sides and the reduction of objects on either side of the horizontal banks.

TASK 51
Judging horizontals
Hold a pencil out at arm's length and try to keep it horizontal. Then judge the angle of the edges of objects seen beyond the pencil. This technique is used by artists to judge the depth of surface angle.

TASK 52
Eye level
Draw on photographs and drawings in magazines the eye level of the artist. The simplest way is either to draw the converging horizontals or to judge how much you see of the top or underside of objects.

Objects viewed end on have regular vertical and horizontal features. Subjects seen set at an angle to the picture plane have a common vanishing point. Looking into a receding space is easily understood if you first establish your eye level, then your vanishing point, to which all horizontals will point.

TASK 53

Understanding eye level
Place tracing paper over this page and draw a corridor, either imagined or observed. Place a chair or table in the composition. In this picture, the vanishing point is approximately 2ft (60cm) from the ground as if you were sitting in a low.chair.

Street scene
Below, the building on the right is seen flat on, the windows are rectangular. The two sides of the street recede from you and have converging horizontals.

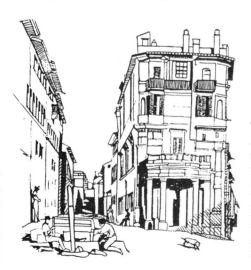

TASK 54

Changing eye level
Turn the book around and redraw the corridor with the vanishing point now 6 ft (1.82m) above the ground level. Compare your two drawings, in the first you should see the underside of the tops of door frames, in the second, you should see down on to window ledges, tables or drawers.

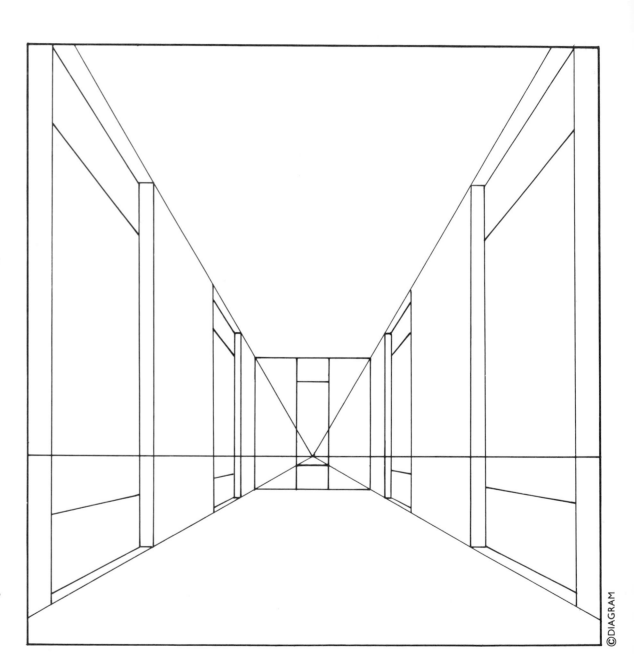

©DIAGRAM

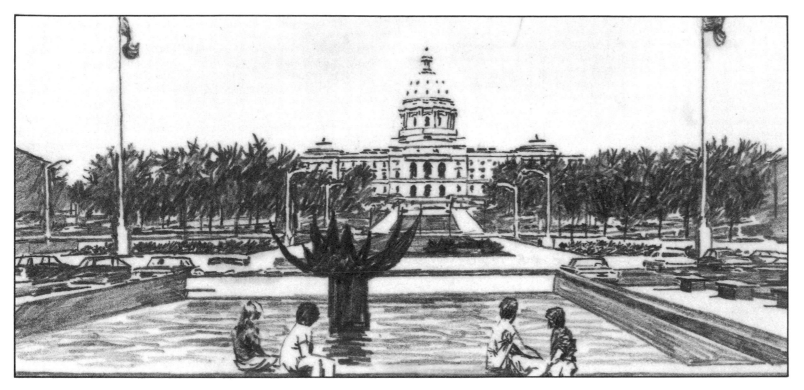

Sloping surfaces

All horizontal surfaces converge on a central vanishing point, but as can be seen from this drawing of the State Capital building in St. Paul, USA, the far distant section of the avenue has a higher vanishing point than those edges nearer to you. This is because the distant section of the road slopes up. It is a tilted surface, so its vanishing point is higher than the foreground lines.

TASK 55

Sloping surfaces

Stand at the edge of a road which dips then slopes up. Notice how the sides of the road appear to meet at different vanishing points. Do a drawing which clearly shows this feature.

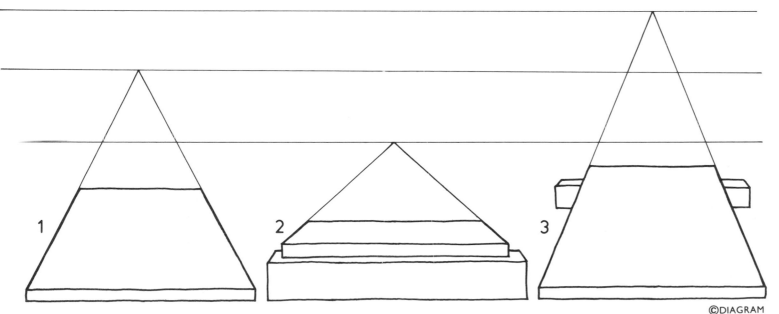

TASK 56

Testing raised and lowered surfaces

1. Place this book with its spine pointing towards you and sitting about 3ft (1m) away. Draw the book's top surface, to establish a vanishing point and eye level. Project the top side edges so they meet at a common point at your eye level.

2. Place other books or objects under the near edge and redraw, noticing the new lower vanishing point. Although your eye level has not changed, the vanishing point will be below this level.

3. Repeat the exercises with the supporting objects under the far edge. This time the vanishing point will appear higher than your eye level.

©DIAGRAM

Two-point perspective

Objects seen at an angle to the picture plane have two independent vanishing points for the two sides of the object. Both points are set along your eye-level line and may be of differing distances from the object, depending on how much of the surface you see.

Moving vanishing points

Right, as you move around an object the two vanishing points move closer to or further from it.

1. Seeing the building end on creates an elevation with no vanishing points.

2a and **2b**. As you move around the building, angles come into view, and their two vanishing points change positions.

3. Faces of the subject seen almost parallel to the drawing's surface have a vanishing point well away from the subject.

4. Faces seen very obliquely to the picture surface have a vanishing point closer to the subject.

Establishing vanishing points

1. First draw your eye-level horizontal. In this case it is the base line of the building.

2. Then hold out a pencil so that it is pointing in the direction of the horizontal sides of one part of the building.

3. Now draw a line extending from the horizontal side till it meets with the eye level.

4. Repeat this on a number of horizontals in the drawing and you will find they all meet at a common vanishing point.

TASK 57

Moving vanishing points

Draw a single building having first extended the horizontals to common meeting points at either side. Then move your position to a more flat-on view and compare the new vanishing points' positions.

Two-point subjects

There are many similar examples among buildings and industrial landscapes.

TASK 58
Two-point subjects
Draw a subject with very pronounced line.work, such as rail tracks with sleepers or a single building seen from a corner point of view.

Viewing position
The convergence of the lines depends very much on your level of viewing the subject. Normally from a standing or sitting position, the ground level is almost horizontal and the roof is sloping downward. But if you adopt a position well above or below your subject, the lines of horizontal recession will change drastically.

Clues
Above, the small detail of window frames, sills, brickwork, all offer an indication of the direction of the lines pointing toward your vanishing point.

TASK 59
Distance
The closer you stand to the subject, the closer are the vanishing points. This can be easily demonstrated by doing two drawings of a subject. The first from over 50 yd (46m), the second from nearby.

TASK 60
Judging eye level
Sit high up on a hill and look down on a group of buildings, or sit at the bottom of a steep hill and look up at a group of buildings. Draw both groups.

©DIAGRAM

One of the major difficulties in constructing an accurate group of converging lines is that the vanishing points are very often outside the limits of your sheet of paper. One simple principle to remember is that the two points for converging horizontals must always be along your eye level and be horizontal to one another.

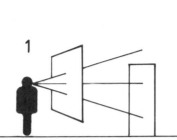
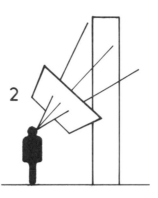
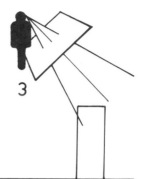

Tilted picture plane
1. Looking at subjects through a vertical picture plane.
2. Looking up at subjects tilts the picture plane upward.
3. Looking down at subjects tilts the picture plane downward.

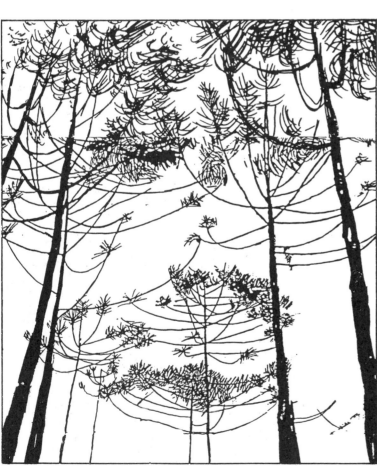

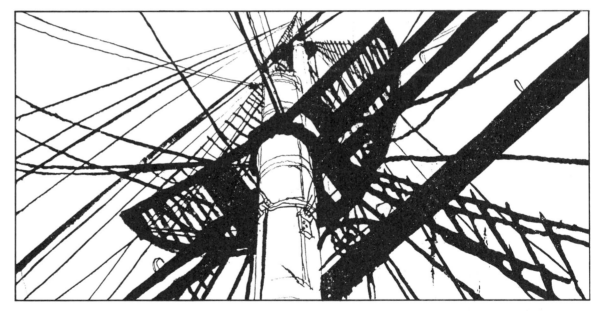

Trees
Left, a group of tall fir trees seen from a position on the ground. This sort of view is one in which you encompass an all-round 'fish-eye' view with all the verticals appearing to converge in the sky. The interiors of tall buildings can achieve the same effect.

Sailing boat mast
An exceptionally complex arrangement of lines as the verticals (the masts), and the horizontals (the yard arms), are further confused by supporting ropes which are at various angles.

TASK 61
Ascending three point
Practice the converging verticals by looking upward inside a tall narrow, building. The interiors of churches, public buildings, or industrial locations offers the opportunity to draw criss-crossing straight lines.

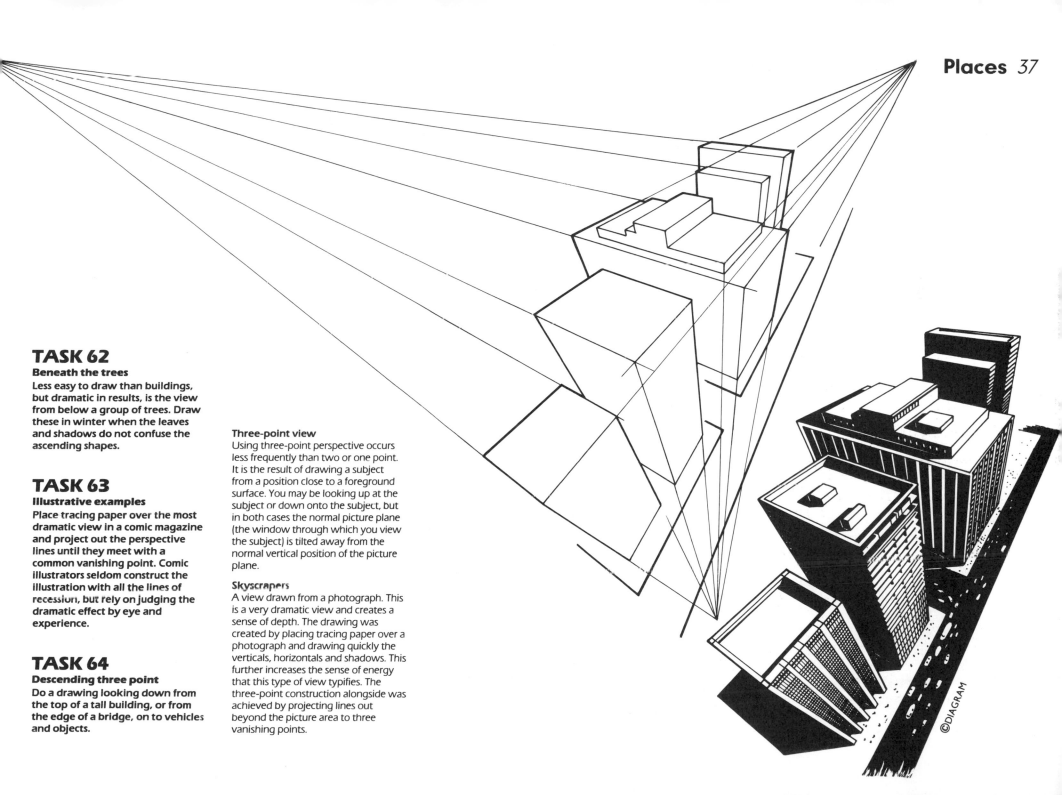

TASK 62

Beneath the trees
Less easy to draw than buildings, but dramatic in results, is the view from below a group of trees. Draw these in winter when the leaves and shadows do not confuse the ascending shapes.

TASK 63

Illustrative examples
Place tracing paper over the most dramatic view in a comic magazine and project out the perspective lines until they meet with a common vanishing point. Comic illustrators seldom construct the illustration with all the lines of recession, but rely on judging the dramatic effect by eye and experience.

TASK 64

Descending three point
Do a drawing looking down from the top of a tall building, or from the edge of a bridge, on to vehicles and objects.

Three-point view
Using three-point perspective occurs less frequently than two or one point. It is the result of drawing a subject from a position close to a foreground surface. You may be looking up at the subject or down onto the subject, but in both cases the normal picture plane (the window through which you view the subject) is tilted away from the normal vertical position of the picture plane.

Skyscrapers
A view drawn from a photograph. This is a very dramatic view and creates a sense of depth. The drawing was created by placing tracing paper over a photograph and drawing quickly the verticals, horizontals and shadows. This further increases the sense of energy that this type of view typifies. The three-point construction alongside was achieved by projecting lines out beyond the picture area to three vanishing points.

©DIAGRAM

Check your work
To help check whether you have understood the simple principles of perspective and their effect on the shapes of subjects you draw, try the following simple Tasks.

Distortion
Distortion of subjects is the result of the position you take up when drawing. Three simple principles to remember are:
1. Objects viewed flat on have correct height and width but distorted depth.
2. Objects viewed at an angle have correct height but distorted width and depth.
3. Objects viewed close up have distorted width, height and depth.

Poor understanding
Below, this drawing is spoilt by the artist not checking the descending horizontals on the two sides of the tower. His drawing 'flattens' the two sides.

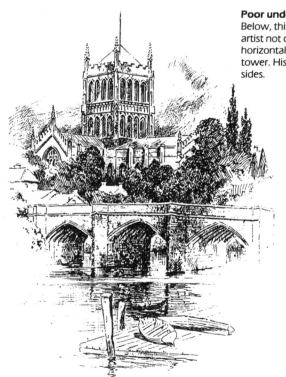

TASK 65
Basic proportional test
Place this book upright on a table with the front cover facing you. Sit on a chair with your eye level parallel to the edge of the table. Draw the front cover of the book. Check that the proportions of your drawing are correct by placing the lower left-hand corner of the book on the lower left-hand corner of your drawing and check that both your drawing and book have similar diagonals.

TASK 66
One-point perspective
Open the book wider than in Task 65 so that you can see some of the back cover. Do a drawing that reveals some of the back and note that the horizontal top edge is now sloping downward.

TASK 67
Two-point perspective
Push back the front cover until you have a central view of the spine, with both front and back sloping away from you. Notice in your drawing that both top edges of the book now slope downward.

TASK 68
Three-point perspective
With the book open to the same amount as in Task 67, move the book forward so that the spine is close to the edge of the table. Move your position forward, as close as possible but retain the same eye level. Your drawing will have a design with sloping sides.

MASTERING TOOLS CHAPTER 3

Drawing tools make a variety of marks, some are more suitable than others for producing the results you have in mind. While out on location, pencils, ball-point pens and felt-tipped pens are best for the task of quick, confident drawing. In the quiet of a studio, pens and technical pens are more appropriate if you wish to build up the detail in your drawing.

Some implements, such as pens, and brushes do not allow you to make corrections, so the results of the marks and their individual effects are more serious than when working with pencils or chalks.

Brushes are not often used on location as they require you to carry water, inks and a mixing bowl.

There are twenty-three Tasks inviting you to concentrate on the quality of the lines and textures of a drawing – the graphic qualities of the art.

- The first four pages, 40 to 43, invite you to work out of doors, taking a small collection of familiar tools and enjoying the weather and the environment.
- Next, pages 44 and 45 are a plan to set up your home studio, a guide to equipping a small work area.
- Pages 46 and 47 introduce you to the methods available for changing the size of an original drawing or reference.
- The six samples of the same subject on pages 48 and 49 are drawings with different tools so you can understand the graphic qualities of a drawing.
- Finally, the review on page 50 contains a challenge. Do a drawing using your less-familiar drawing hand.

When working on location you will need tools that are reliable and easy to use. Do not take tools that cause you difficulties and with which you are unfamiliar. Carry a small shoulder bag, large enough to contain your tools and your sketch pads. When on location the bag can be pushed round to your back leaving your hands free to hold the drawing pad and pencil.

Paper
When you first begin sketching out of doors, you will find a sketch pad is preferable to working on paper fixed to a board. The pad enables you to turn quickly to another subject, and it is a more convenient way to store the drawings.

Drawing on location
Below, a pencil drawing of an old agricultural machine. During the drawing, the weather turned to a heavy shower so the second drawing, opposite left, was made from the shelter of a barn using pen, brush and ink.

Tools create style
Opposite page, sectional details from two drawings, the first (center) a pencil study on rough paper using a soft pencil. The second (far right) a pen and ink study on smooth thin paper.

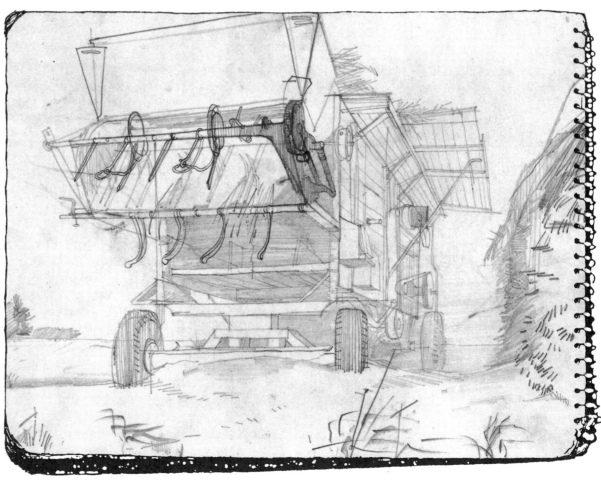

Outdoor tools
You will need a small box to hold the tiny objects, such as erasers, board-clips and those that damage with travel, such as chalks or pen nibs. I have found that plastic date boxes are good as they have a tight-fitting lid. Individual tools, or a quantity of charcoal wrapped in paper, can be stored in a plastic toothbrush box.

Take pencils and do remember to take a pencil sharpener or penknife. Place brushes in protective covers. You can make your own brush cover by rolling a tube of stiff paper the size of your brush and sticking it together with tape or glue. Remember to lick the end of the brush each time you place it in the cover to prevent the outside hairs from being bent backwards in the tube.

Four Tasks

Four Tasks to introduce you to the marks tools make. Each should be of the same location and from the same position, so select a view where you can study without disturbance and can spend long periods of time in some comfort, such as sitting on a wall.

TASK 69
Pencil

Do a series of studies first with a soft pencil on rough paper, then with a hard pencil on smooth paper.

TASK 70
Charcoal or crayon

Do a series of studies each on different colored papers. The tonal effects of working on dark paper, and adding highlights with white chalks is often very effective.

TASK 71
Pen and ink

Repeat the subject study and work one drawing very quickly in pen. Make a second study taking more time and adding lots of detail. Draw on smooth strong paper.

TASK 72
Brush and ink

Your final drawings of this subject should be on thick paper, strong enough not to buckle when you add areas of diluted ink with a brush wash. If the paper is smooth enough, you can work the final drawing using both pen and brush.

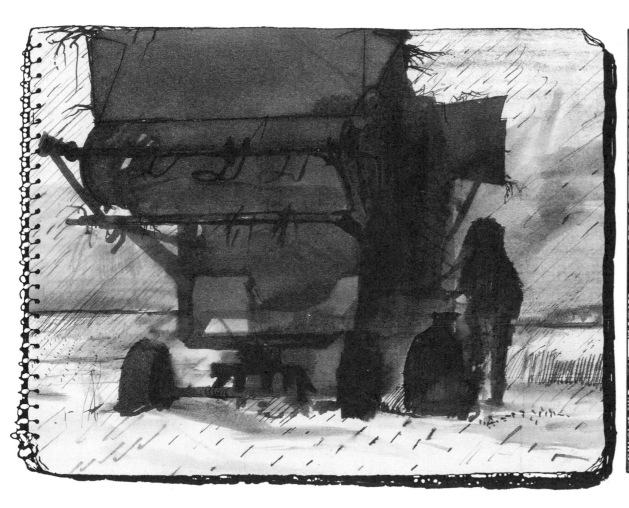

©DIAGRAM

There are two objectives when drawing out of doors. The first is to record a subject as accurately as possible, and the second is to try to capture some of the atmosphere of the view. Either may be your prime interest, and certain tools are more suited than others to achieve your aims.

Street scene
Below left, a pencil study of a winter street scene. The moving figures and the misty shapes of roofs are best recorded on rough paper with a soft pencil.

Buildings and trees
Below right, the strong hard light of the Cuban jungle is more easily captured with a dark felt-tipped pen line on smooth paper.

Exploring atmosphere
Four Tasks to explore the atmosphere of the same location. Choose a spot where you can shelter from bad weather, and on which there are, on occasions, a gathering of people. Choose perhaps a street market, a bus or rail station, a park, or a popular beach.

TASK 73
Detail study
Draw a scene on a quiet sunny day with maximum detail in your study. Record as much of the subject as you have time for, spending about two hours on the drawing.

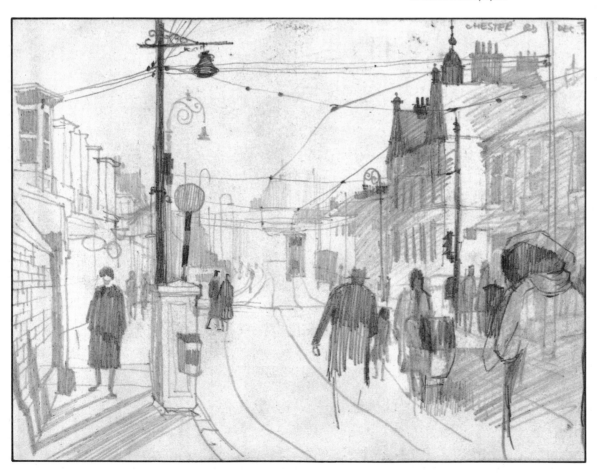

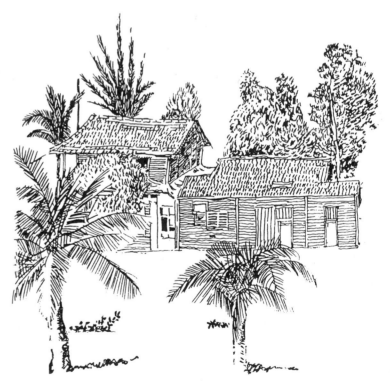

TASK 74
Atmosphere study
Draw the same scene on a dull, cold, damp day, or early in the morning, or at dusk on a winter's day with poor sunlight.

TASK 75
Crowd study
Return to the scene at a time when it is most busy, and do a series of crowd studies, working fast, and keep a number of small drawings going at the same time.

TASK 76
Combined study
Using all three studies, do a drawing at home in which you include a great deal of detail, a sense of atmosphere, usually achieved with tones and adding people to give the drawing life.

Bar scene
Below left, the smoke-filled Irish tavern is best captured with smudgy soft pencil marks on rough paper. Do not worry about errors when trying to capture atmosphere: it is the mood of the drawing, not its detailed accuracy, that is important.

Winter gardens
Below, brush and diluted inks working on a cold morning from a high window. Normal pen inks must be diluted with distilled water, as normal water causes them to produce blotchy tones. You can carry a bottle of ink and a bottle of distilled water, mixing small quantities on the lid of a cosmetics compact or a food jar lid.

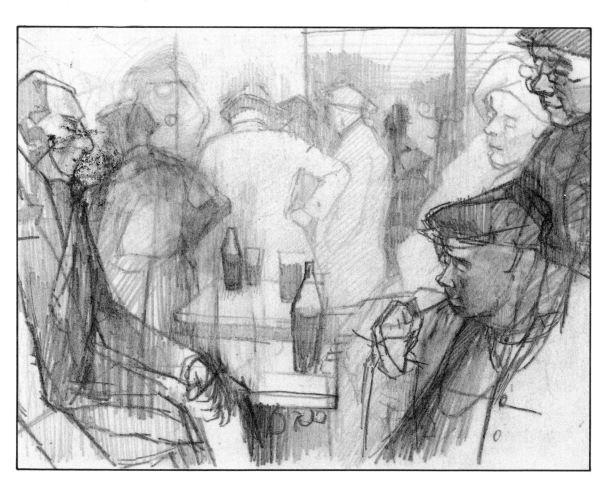

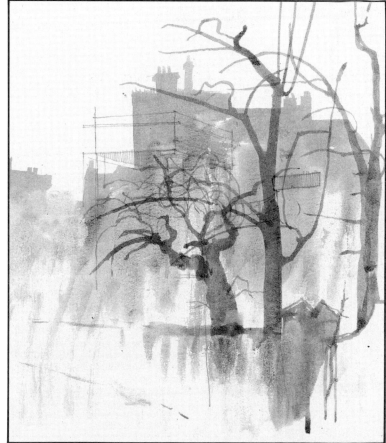

©DIAGRAM

44 Drawing indoors

Many successful landscape drawings have been produced indoors, without any direct reference to the real world. Using either photographs or studies made on location, you can build attractive compositions by combining details and information from more than one source.

Studio tools
Left, all the normal location tools are useful at home, but two additional ones to have when working indoors are a blow spray for fixing pencil and charcoal drawings and a scalpel and a supply of blades. As technical pens cannot produce a varied line, so you must buy a selection of pens to obtain different line thicknesses.

Technical pens
Most art supply stores now stock a variety of technical pens. These produce an even thickness of line – usually in black ink. They are used mostly by artists whose work is intended for reproduction. They require care and attention as the pen only works successfully on smooth surfaces, and the pen clogs and does not produce even lines if the nib is exposed to the air for a while. Great care must be taken *NOT* to apply pressure on the nib as the drawing line should only be the result of contact between the nib and the surface.

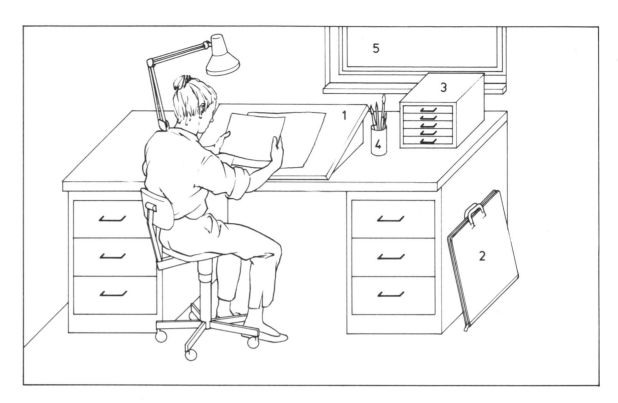

Your work area
Most people can spare a small permanent space for working. A hobby corner. More important than the size of the space available is the efficiency with which you use the space. The basic requirements are;
1. An inclined drawing surface so that you are not leaning over the work.
2. A place to store drawings, whether a plan-chest or a portfolio.
3. Small drawers to store tools and notepaper.
4. Jars to hold the tools which you most frequently use.
5. A natural light source, usually from the front and left side if you are right-handed.

Working practice
Remember some simple rules when you are working.
a. Everything should be within easy reach of your drawing surface and you should be able to sit comfortably for long periods.
b. Allow no distractions, so sit facing a wall or a quiet view.
c. Always keep your work area clean and free from clutter.
d. Store away tools not in use.
e. Buy serviceable, not glamor, tools. Never buy cheap tools as these very quickly deteriorate.

TASK 77
Work area
Make a permanent work area with a surface of approximately 2 ft 6 in × 5 ft 0 in (76.2 × 152.4 cm). One very successful work surface can be made from a door laid over two small filing cabinets, then covered with hardboard and linoleum.

TASK 78
Work efficiency
Sort out all your pens, pencils, brushes. Discard old worn-out tools. Sort the very small objects such as paperclips, penknives, erasers, into a small drawer or box. Regularly, maybe once a month, wipe down all the surfaces of your work area to keep them free of dust. Regularly wash out the water jar and mixing dishes.

Studio techniques
Working indoors enables you to add a great deal of detail to your study, which would require lengthy attention on location.
Left, a drawing of buildings in New York made in the 1920s by Jonathan Ring.

Drawing surfaces
Papers, cards, boards, all offer a wide variety of surfaces. Most stockists have paper samples and it is advisable to buy very small quantities of materials until you are confident that you can get the right quality of line from your tools on various surfaces.
A simple guide is;
1. Pencil works well on most papers but slides and is weak on smooth surfaces.
2. Ball-point pens, felt-tipped pens and office pens of all types work on most papers.
3. Pens work best on smooth surfaces; they do not work on rough textured surfaces.
4. Technical pens should only be used on smooth surface papers.
5. Brushes must only be used on strong thick papers. Thin weak papers will only buckle and cause blotches when water is applied.

Fixing
Above, pencils, chalks, crayons and charcoal drawings should always be fixed to prevent them from smudging. It is better to use a solution of fixative which is sprayed on to the drawing with a blow spray. The pressurized canisters of spray fix damage the atmosphere and are dangerous when you inhale the fine spray.

TASK 79
Storage
Check that all your pencil, charcoal and crayon drawings have been fixed and are stored. Where necessary interleave some with tissue paper to prevent them rubbing together.

TASK 80
Supplies
Collect as many different types of paper as you can – samples of rough, smooth, dark, light, cheap, expensive, and whatever other paper surfaces you can find. They often add a unique quality to your drawings.

©DIAGRAM

This book does not contain drawings. It uses reproduction of drawings – often the difference in quality can be quite striking. Four factors affect the appearance of the reproductions. Their size in relation to how large they were originally drawn. The color of the original drawings. This ranges from the color of the paper originally used to the tones originally produced by the pencils, brushes and crayons. Then there is the texture of drawings, some of which may have been done on a rough surface, but are now reproduced on a smooth surface. And, most importantly, how well their original quality is captured in the quality of the printing of this book.

Size
When I was 12 years old, I frequently copied from illustrations in books and magazines. While a student, I was shocked when examining original artwork to see it was often drawn much larger than its reproduction. Somehow I felt this was cheating. In later life, my experience taught me that successful illustrators may have deliberately drawn their originals larger but while retaining the idea of how it would appear at the smaller size.

TASK 81
Judging scale
Estimate the original size of drawings in this book or in other books. One clue is the size and nature of individual lines.

Changing sizes
You can change the size of your drawing or reference by a variety of methods, some very laborious, others much simpler.
1. Estimating the new proportions by use of diagonals (**A**) or protractor (**B**).
2. Enlarging by the square-up method.
3. Enlarging by pantograph (**C**).
4. Enlarging by a lens.
5. Photographic enlargement.

Proportional enlargement
When enlarged or reduced, a drawing has a common diagonal with its original size. This principle helps when thinking about the size change. However, the technique only gives you a new width or height change. It does not help with details. A small wheel-like scale is available called an enlarging protractor, which enables you to calculate the new dimensions of a drawing. For example, if you change the width from 10 to 15 units, then by turning the discs to matching these two numbers all other alignments on both scales are proportionally changed, e.g. 8 to 12, or 6 to 9.

Enlarging protractor
Above, the plastic disks are used to find the relationship of measurements when enlarging or reducing.

The Pantograph
A series of parallel rules which proportionately change plotted points on a drawing.

Actual size
Examples of details from drawings within this book are printed here actual size. Can you locate the drawings in the book? All the examples selected in this book were, of course, drawn prior to publication, with no intention of being included and were produced in a wide variety of sizes and styles.

Basic squaring up
This method is more than 3000 years old!

Either draw a series of squares on to your drawing or, preferably, on to a covering of tracing paper. On your intended new surface draw a second series of squares, this time to the new size. Slowly and carefully copy by hand the intersections of the major elements of the design, transferring the shapes to the new grid. To avoid confusion, greater accuracy is achieved if the drawing is turned away from you so that you do not read the information other than as shapes.

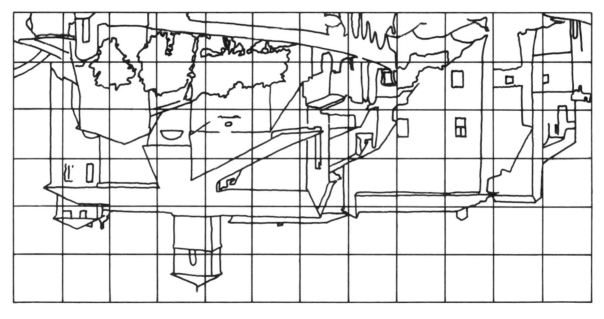

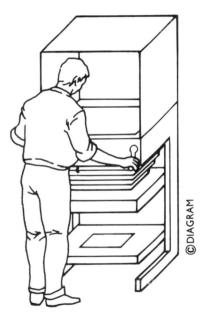

TASK 82
Artists' originals
Make an effort to visit art galleries and museums and examine artists' original drawings. Very often these are not on display, but are stored in archives of the collection and can be examined upon request.

TASK 83
Re-scaling
Re-scale one of your less complex drawings using the squared-up method, producing two versions, one smaller than the original and one larger.

TASK 84
Photocopy
Take one of your most detailed drawings, preferably one you did with a pen, to a photocopier service, and buy a series of enlarged and reduced versions of the original. Pin them up on your notice board and compare the tonal qualities.

Studio enlargement
A lens-like machine, which can enlarge or reduce your original by projecting the new size on to a glass screen from which you can make copies.

Photograph enlargement
Your drawing can be photocopied at a new size

©DIAGRAM

It is important that you learn to understand the graphic qualities of drawing. These are marks made by various drawing instruments and the manner in which the marks are made. Pencils, pens and brushes all produce different effects and each is more suitable for certain tasks than others. Many beginners copy published drawings using tools different from the original artists, so the resulting copy has a different drawn quality.

Six examples
A detail, actual size, of the drawing on page 20 and using different tools or techniques.

1. Smooth pencil work drawn very carefully, slowly building up the tones.
2. Pencil on rough cartridge.
3. Ball-point pen.
4. Technical pen, cross-hatched.
5. Technical pen, built up of dots.
The first and last two solutions are not suitable styles when working out of doors as they require time and care.

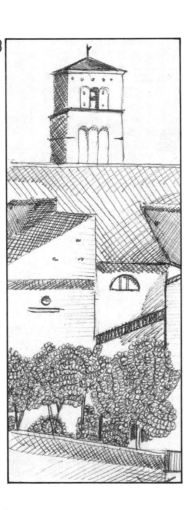

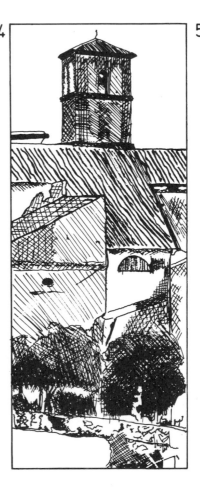

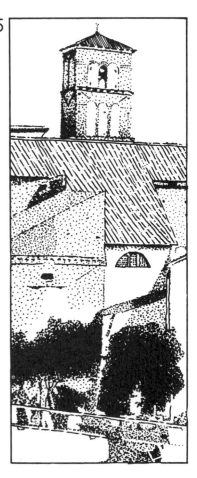

If you continue the subject of landscape drawing you are following in the footsteps of many great artists. Remember, there is no such thing as a bad drawing. There are only drawings you are not pleased with. If you work hard, examine the subject carefully and record accurately, you will produce good drawings. Strangely the fun you get from your work is captured in the quality of the lines on the paper. Whatever you discover, you reveal.

TASK 117
Observation
Do a series of drawings sitting in the same position. Each drawing should be at a different time of the day, but of exactly the same scene. It may be from your window, or from a bench in the park. Be sure you do each study without reference to the previous studies. You will find that you notice some slight difference of aspect each time you scan the subject. The overall effect of perhaps five drawings, each in detail, can produce an overwhelming impression of a place.

TASK 118
Time
Reality is never constant. Lighting, weather, events, your reactions, all interact to produce unique impressions of a scene. Do four drawings from the same spot, each drawing at least three months apart. Choose perhaps public holidays scattered through the year. The comparison of the studies is made more striking if they contain plants or trees.

Scale
In Task 106 you had to locate one or other of two figures. The drawings were made from a photograph and the figure in the foreground marked **A**.

Focal point
The painting by Bruegel relies very strongly on the foreground group of figures. They are walking into the picture space. The middle distance has lots of tiny figures who not only hold our interest, but somehow invite us to move closer to the picture to see what each is doing.

TASK 119
Research
Visit art galleries, collect books on art, cut illustrations from newspapers and magazines. Study the work of artists you admire, copy everything of interest.

TASK 120
Tradition
Buy a print or drawing by a living artist you admire or whose work you like. This maintains the tradition of art. You become a sponsor. Never buy as an investment. You can only make money, or lose it. Buy a picture because you like it.

TASK 121
Records
Check that all your drawings are marked with the location, date and your signature. You must constantly re-examine your work, but you must have an inner pride of your achievements to spur you on to more studies.

TASK 122
Pride
Select your very best study. Spend money on a professional service and have your drawing mounted and framed. Display it in your home.

TASK 123
Continuity
Begin a life-long enquiry into one feature of your locality and whenever possible do a study of it. It may be a park, a river, beach or just your neighborhood.

TASK 114

Textures

Working with crayons, chalks or soft pencils, select a subject which has a strong textural surface such as rocks, trees, fields or hills. Try to select a subject you can study from a frontal position so that you are not distracted by recessional space problems in your drawing.

Patterns of detail
Below, the Swedish artist Sven Olov Ehrén used a method of drawing whereby all the edges are thick lines and all the surfaces flat tones.

TASK 115

Linear net

Convert any drawing in this book or any of your earlier Tasks into a flat network of lines. If you use a thick pen or pencil line, you will produce a strong design. If you use thin lines, the pattern-making quality will not be too clear.

Patterns of shape
Below, a forest scene. Branches, foliage and shadows are all fused into a pattern of shapes. The most extreme form of drawing is to reduce all tones, colors, textures, forms and shades to shapes.

TASK 116

Shapes

Convert any drawing in this book or any of your earlier Tasks into a pattern of shapes. Use black and white in large areas and avoid details. To copy a drawing successfully turn it upside down, then you can consider only the shapes and not their intended descriptions of reality.

©DIAGRAM

The first pages of the study of landscape began with the problem that all drawings are flat. They are marks on the surface of the paper. The artist uses various techniques to create the illusion of space. These two pages offer ideas for exploiting the paper's flatness. Your drawing becomes a pattern of shapes, and not a description of reality.

Patterns of light
Below left, old buildings drawn on location. By emphasizing the shadows the sense of space suffers. The interest is maintained, however, by the patterned quality of the drawing.

TASK 113
Light and shade
Convert one of your earlier drawings in to a design of shapes. Follow the edges of the shadows and fill in large areas of the composition by selecting a low light source. Tasks 14, 15 and 16 will help you start on this method of creating a design solution to a drawing.

Patterns of texture
Below, rocks on a coastline. Our interest is held by the textures of the rocks, recorded with a soft pencil and use of smudging with my fingers.

Tonal effects
Left, black trees against a white sky. White sheep against a dark ground. Each is contrasted against the other to create a very interesting effect.

TASK 111
Tonal effects
Do a drawing using only one value and white, no grays. Make a pattern of the landscape matching darks against lights. Choose a simple composition with very few elements to avoid producing a very complex image.

The view
Right, a 19th-century Japanese book illustration. The view of the path interrupted by the foreground tree excites the interest and makes the eye zig-zag into the composition.

TASK 112
The view
Find a location where you can select a very startling view of the subject. This is often achieved from a high or low vantage point, but can also be the result of how you cut the sides of the subject.

© DIAGRAM

A sense of energy, the dynamics, in a drawing can be achieved by a variety of methods, or a combination of methods. The most common techniques are: the subject itself; the view chosen by the artists; the tonal effects of the drawing; and the technique by which the drawing is produced.

TASK 109

Technique

Do a drawing using a very unlikely drawing instrument. For example, sharpen the wooden end of a pen or brush and use this crude implement dipped in ink or paint to do the drawing. Or simply do a pencil drawing without resting your wrist on the paper. At all times only allow the tip of the pencil to touch the paper. This produces a very shaky nervous line.

The technique
Right, this is not a drawing of a landscape, it is a collection of marks made by dabbing cloth first dipped in ink onto the surface of the paper. The method of drawing has created a dynamic of style which would be hard to create with a pencil or pen.

Idea
Right, this is a study of the Ponte Vecchio in Florence. Such a well-known subject is made interesting by exploiting the effect of the reflection of the bridge which creates a structure unfamiliar to us.

TASK 110

Idea

Draw a landscape while sitting in the car looking into the convex reflector mirror. Try to capture the distortion of shapes. Think of some subject which offers this unique and arresting approach. Try standing on a bridge and drawing the view directly below of people or vehicles. Or find a scene where the lighting effects are unique.

Focal points
Human beings as focal point in a composition. This pencil study of a famous painting of a winter scene by the 16th-century Flemish artist, Pieter Bruegel, takes all the dynamics out of the picture. There are no figures here. The original had a strong human interest. Can you guess where the artist placed the figures?

TASK 107

Locating figures
Place tracing paper over this picture and copy the basic elements. Then add figures. Compare your results with a small study of the painting on the review page of this chapter.

TASK 108

Landscape artists' work
Trace the major elements of the compositions of famous paintings of landscapes that are reproduced in books. Then add in solid outline the position of the figures in the composition. This reveals the inner dynamics of the painter's subject as the figures stand out from the context of the space of the picture.

©DIAGRAM

One of the most important aspects of a composition is the presence of people in the picture. Figures help to create an illusion of space by their reducing size, and they add a sense of scale to the surrounding objects. Artists have always used the presence of figures and even when reduced to the simplest of details on a drawing, they help to create life in the composition.

TASK 105

Sketch books

Keep a small note pad in which you regularly sketch single figures or groups. Try to capture the basic shapes without recording too much detail. These notes will be invaluable when you come to add figures to your more developed compositions.

Scale

Figures in a landscape give scale to a scene. You can judge the size of objects against figures, because we all know the normal height of a standing figure.

TASK 106

Estimating scale

Which of the two figures (below) would be appropriate in the foreground of the beach scene? The answer is on the review page of this chapter.

Four compositions through a viewing frame.
When out on location, you can frame the scene either with your hands or through a small hole cut in a card.
1. Scene close up to form an intimate view.
2. Scene at long distance to form a deep composition.
3. Scene selected to create spatial tensions.
4. Scene selected to give impression of movement.

TASK 103

Viewing
Make a viewing frame and take it with you on your next location trip. Try doing a series of ten-minute sketches of different compositions of the same view.

Recessional space
Far right, most compositions contain foreground (**A**), middle ground (**B**), and distance (**C**). Greater interest can be achieved by balancing these elements. Right, this 19th-century drawing sets the scene as if it were a stage set, with each part flat and overlapping the others.

TASK 104

Extended compositions
Place tracing paper over landscape photographs in magazines and draw the basic compositional elements. Mark foreground, middle distance and far distance as three distinct areas. One way to accomplish this is to imagine you have to paint three flat screens for a stage play, each as part of the composition.

© DIAGRAM

The format and form of the picture create special effects. The shape of the frame and the positions of the elements within the frame, both interact to influence the composition. When on location, or planning a picture at home, use a rectangular frame to judge the picture area.

The shape of the frame
Left, three views of the same landscape, each within a different rectangle. Each creates a different impression of the composition.

TASK 102
Panoramic views

Make drawings of open fields, sea scapes, or from high up in an urban area. Make your study at least four times as wide as it is high.

Outward or inward responses
Above, this drawing of distant fields is wide and even. The eye roams over the landscape to settle on different parts of far distant fields.
Left, this scene from under a bridge draws the viewer into the picture. Attention is directed towards the vehicle just over the crest of the road.

TASK 101
Recessional compositions

On location draw a view through an arch, under a bridge, or into some confined space.

Spatial tensions
Below, three similar frames in which the composition varies by the way the elements within the frame are positioned. There are three factors which interrelate. The position of the boats, landscape and edge of frame to create different styles of composition.

Sitting comfortably
This sketch by the Dutch artist Vincent Van Gogh, must have been made from a seat outside the cafe. Try to sit where you can enjoy the experience of observing people and places.

Recessional subjects
The best subjects of deep space to record are those containing small elements of diminishing patterns, such as cobblestones, tiles, paving stones or planks.

Stockholm street
Right, this sketch, based on a Swedish artist's painting, shows that he must have stood on the edge of the sidewalk to avoid being interrupted by the passersby.

Industrial scene
Below, an old, abandoned dock scene offers ideal quiet to study the shapes, as this sort of location is usually undisturbed.

The position you take up when out drawing will very much influence the resulting drawing. Sitting is preferable to standing, to occupy an unobtrusive position is better than a conspicuous one. Try not to draw attention to your activities, unless you like sketching in front of an audience of passersby.

Mosel Valley, Germany
Below left, a view from a bridge looking up at the hill-top castle. Below, the same subject viewed from the top of a hill with the same bridge in the distance.
Each drawing creates a different impression of the location.

TASK 97
Point of view
Do two drawings of the same subject, each from a different point of view.

Boats, Hong Kong
When undecided about a particular view of the location, try drawing some of the individual elements in the scene. This can be helpful as these studies may be used in later compositions.

TASK 98
Collecting details
Keep a small note pad with you constantly and jot down individual subjects, such as boats, cars, trees, people. These can be of use in later studies.

TASK 99
Uninteresting subjects
Visit locations which at first would seem to offer very little interest, such as Industrial Trading Estates, residential areas in the suburbs, motorways.

TASK 100
Recessional subjects
Visit a location that offers a view deep into the composition. Examples are looking along a street, or a river, or rail tracks. Use the diminishing details as a device to draw the observer into the subject.

TASK 93
Skyline
Do a tonal study of the edges of the subject against the sky. You can copy this photograph or draw the skyline using a view from your window.

TASK 94
Buildings
Do a study of a particular building in this photograph, or a building you can see from your window.

TASK 95
Texture
Do a texture study of a part of this photograph. Compare water, trees and buildings to each other.

TASK 96
Framing
Cut two L-shaped pieces of card of similar size and place these over the photograph and select an area to draw. By changing their proportions and moving them around you can reveal other interesting compositions.

©DIAGRAM

Selecting what to draw is often the hardest part of the task; for example, where to look, which section to choose and which feature to examine. Beginners often feel inhibited by the complexity of the real world. One simple method of selection is to direct your attention to one aspect of the subject. Draw the skyline to the exclusion of the middle distance and foreground.

Draw a particular building or object on the landscape. Draw only the textural differences and light and shade effects. Draw passing events. This last activity – sketching – requires experience as the events pass and memory of them must be retained in your mind's eye. What is important is to make your choice of approach before you start, and begin your drawing with a particular viewpoint.

Framing
Left, when out sketching make a frame with your two hands and view the landscape through the center area.

Five examples of styles
A. Horizon study
B. Building study
C. Texture and tone study
D. Sketching
E. The larger illustration is an example of in-depth study, which involves drawing the space which is moving into the picture and away from the viewer.

B

C

D

E

CONSIDERING DESIGN CHAPTER 4

This chapter is devoted to considering your drawings as rectangles containing a network of shapes, tones and lines. Also, how to think of your drawing as a graphic (flat) object. The thirty-one Tasks will help you enjoy the pattern of your pictures, that is, your view of the subject through the picture frame.

We also look at those factors that influence your drawing: selecting subjects; selecting areas of the subject; selecting the position of the subject within your picture frame; and selecting the qualities of the subject.

- We start with what to draw. The first four pages, 52 to 55, help you decide where to stand when on location.
- What should I choose for a composition? Pages 56 and 57 offer you the chance to consider the overall effects of the position of the elements in your picture frame.

- Pages 58 and 59 are concerned with bringing your pictures to life. So often beginners are afraid to include figures in their studies. As figures often move, and as they seem harder to draw, they are left out. But, the presence of human activities helps set the scale and tone of the composition. Figures are often a focal point in the composition.
- Pages 60 to 63 explore the design of your drawings. How to think of the image as a 'picture' and consider its texture, tone, pattern and style.
- The final page of this chapter invites you to review all the 123 Tasks devoted to drawing landscapes.

Understanding technique
This chapter was about how drawings are produced – the technique of drawing. Never be over-influenced by the technique: what matters with a good drawing is how you see the subject and that you understand how to capture what you see. It should be your vision of the world.

TASK 89
Recording the technique
Mark in a soft pencil in one corner of each of the previous 88 Tasks the method by which you did the drawing. If most are in pencil, consider using other tools for later Tasks and even redoing some of the earlier Tasks, using pens or brushes.

TASK 90
Conversions
Turn any previous Task into a brush drawing.

TASK 91
Uncomfortable tools
Try redrawing a Task in chalks on colored paper, or with a fine pen, building up the tones by cross-hatching.

TASK 92
Handwriting
Do a drawing either from location or photograph using a pencil but holding it in the hand other than the one normally used for drawing. You will immediately feel unsure of the lines and need to concentrate much harder on the effects.

The importance of tools is that they can very easily undermine your confidence. You feel uncomfortable with some implements. Try always to be able to use as many tools as possible, as this widens your graphic abilities.

Handwriting
Top, a very fast ball-point pen study using my right hand, which is my normal drawing hand. Below, another drawing using my left, unfamiliar hand. The second drawing took much longer as I had little confidence in the ability to make the correct marks.

©DIAGRAM

Time influences style
6. A fast sketch using felt-tipped pens: the flat areas are produced by a broad soft marker and the detailed areas by a felt-tipped pen with a small point.

TASK 85
Exploring tools
Copy the photograph below using a pencil, then repeat the task using a pen or brush. Compare the different effects. The same experiments should be made on location, choosing a view that offers you lots of detail.

TASK 86
Artists' techniques
Copy the drawings of famous artists using the same tools as they did to achieve similar effects.

TASK 87
Varying techniques
Copy the drawings of famous artists, using different tools from those used by the artist. It is great fun to reproduce with a brush a drawing originally produced in pencil. You will find that tools very strongly influence your style of drawing.

TASK 88
Time
The speed with which you produce the drawing also influences the style. Do another drawing of the photograph below taking only five minutes to record as much detail as possible. Use any tool you wish.

6

©DIAGRAM